Painting Pets

WITH WATERCOLOR

English translation © Copyright 1995
by Barron's Educational Series, Inc.
Original title of the book in Spanish is *Animales Domésti-
cos a la Acuarela*
© Copyright 1994 by Parramón Ediciones, S.A.
Published by Parramón Ediciones, S.A., Barcelona, Spain

Author: Parramón Ediciones Editorial Team
Illustrator: Vicenç Ballestar

All inquiries should be addressed to:
Barron's Educational Series, Inc.
250 Wireless Boulevard
Hauppauge, New York 11788

Library of Congress Catalog Card No. 94-46432

International Standard Book No. 0-8120-9293-7

Library of Congress Cataloging-in-Publication Data
Animales domésticos a la acuarela. English.
 Painting pets with watercolors.
 p. cm. — (Easy painting and drawing)
 Prepared by Parramón Ediciones Editorial Team, illus-
trated by Vicenç Ballestar, and translated by Barron's Edu-
cational Series, Inc.
 ISBN 0-8120-9293-7
 1. Animals in art. 2. Watercolor painting—Technique.
 I. Ballestar, Vicenç. II. Parramón Ediciones. III. Title.
 IV. Series
ND2280.A5413 1995
751.42'2432—dc20
 94-46432
 CIP

Printed in Spain
5678 9960 987654321

WITH WATERCOLORS

Painting Pets

BARRON'S

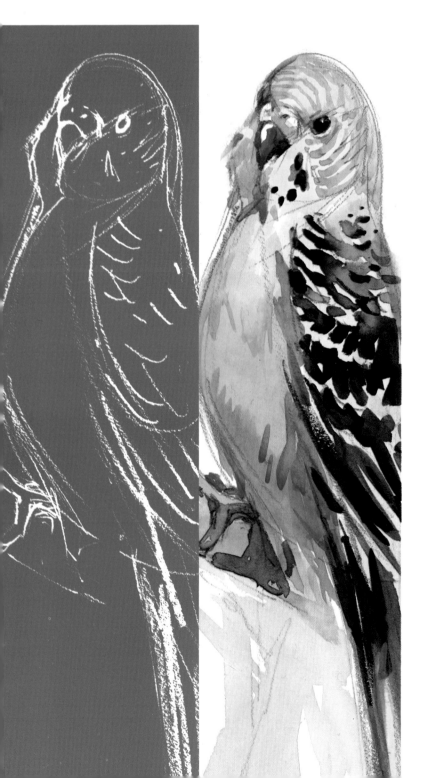

CONTENTS

This book is dedicated to some very likable pets who provide companionship and share the lives of their owners. We suggest that you undertake a series of simple watercolor exercises whose technique we will explain step by step so that you won't have any trouble following us. You'll get to know these animals and, at the same time, learn about painting with watercolors.

I can't avoid a word of advice: In an attempt to finish your painting, don't rush. If at first you see that it isn't turning out well, be patient. Don't get discouraged. We all go through this. With determination, persistence, and will power, you're sure to make more progress than with impatience and discouragement. Have you ever thought of all the work that the great masters destroyed because they weren't satisfied with it? Please believe me, don't try to go too fast. Don't try to learn everything in a few days. It's better to go step by step and progress slowly. Whatever doesn't turn out well today, might turn out better tomorrow—or perhaps the day after tomorrow. What's the difference how long it takes? The point is to make progress.

This volume contains suggestions, explanations, observations, and basic advice for anyone who wants to practice painting. Although the universal and classic laws of painting guide you, there is a great deal of personal input. Painting is learned, but above all it is felt, it is lived. Please, don't limit yourself to following our advice in a purely mechanical fashion. Try to get involved in the work, in what you paint, in the world of color. Give it feeling. Without a doubt, the experience you gain by paying close attention to what you're doing and the time you spend contemplating the work will teach you and be a great help in the future.

Listen to the advice that we give you, try to assimilate it, and sift it through the sieve of experience. I'm sure your results will be very satisfactory.

Come on and have fun!

Jordi Vigué

WATERCOLOR MATERIALS

*O*n these two pages you will find the majority of the materials needed for painting with watercolors. Of course, you won't need them all. You'll have to choose what is the most appropriate for your taste and painting style.

Artists' watercolors usually come in two different forms: tube colors (A) or dry colors in pans (B). There are also containers of liquid watercolor (C), which I don't recommend because of their high intensity and aniline content, almost impossible to eliminate or tone down once applied to the paper (they are usually used for illustration).

Flat and round brushes (D), pencils (E), eraser (F), pencil sharpener (G), blocks of watercolor paper (H), thumbtacks and clips for attaching the paper (I), cutter and razor blade (J), sponge to dampen the paper or lift the color (K), glass or plastic jar (L), metal watercolor boxes that contain colors in pans or compartments for watercolors in tubes and porcelain plates (LL).

WATERCOLORS IN BOXES

There are two ways in which watercolorists generally use their palettes. If the painting they are going to do is a large size, they will use tube colors and a watercolor box with compartments. They will also use large brushes, which would be inappropriate for watercolors in pans. If the watercolors we are going to paint are usually medium or small size, then the dry colors in pans are preferable because they last longer. Nevertheless, if you paint carefully, I would recommend painting with the tube colors for all sizes. You can also buy small containers of watercolors in half pans, a brush, and a small pocket-size plastic bottle, very useful for making on-the-spot sketches.

BRUSHES

There are many different sizes and shapes of brushes on the market. The sable ones are highly recommended. They are expensive; however, if you take care of them, the hair and the fine point will last longer, no matter what size they are. There are also ox-hair brushes (a softer brush, very useful as a round brush in a large size), and deer-hair brushes (Japanese). Synthetic brushes are now on the market, sometimes mixed with sable. These are cheaper. I would recommend the ¾-inch or 1¼-inch golden sable brushes for their longevity and strength; they do a good job of bringing out color.

COLORS

As is the case with brushes, the market also offers many brands of watercolor paint. To begin with, it is advisable to buy a medium grade of paint because the less expensive student grade is difficult to use. Once they are dry, the cheaper paints often fade, thus ruining the work, or the high aniline content may stain the paper.

PAPER

We can also say a word about paper. The choice of paper should be based on the type of watercolor you're going to paint. Prices vary, as do weights and sizes. As is often the case, the price is determined by the quality. Loose sheets of paper are available, and there is a great variety·of blocks where the paper is glued together. They are easy to use because the thick block makes a good drawing board. The sheets of paper can be separated with a razor blade or a knife, pulling gently along the sheet you want to remove. These blocks also come in different thicknesses and sizes, and most of the brands are reliable.

L

C

D

K

A

B

LL

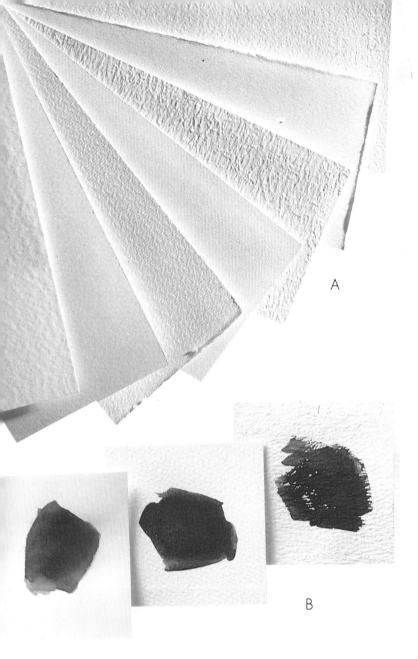

A

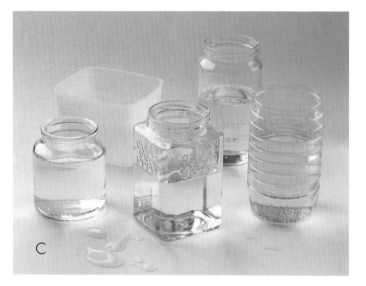

C

Our selection will be influenced by our personal tastes and our style of painting.

Look at photograph B. We have made brushstrokes on three different kinds of paper: rough, cold pressed or medium texture, and hot pressed or smooth. On rough paper, brushstrokes have an irregular quality, leaving areas of white paper showing through. In contrast, paint flows more evenly on the smooth surface of hot-pressed paper. Try all three kinds of paper, and then choose the one that is most appropriate for your style.

WATER CONTAINERS

Any container will do, from a cup to a glass; you can use any of the ones shown in photograph C, as long as it has at least a one or two quart capacity so that the brush can be rinsed several times. It should have a wide mouth and a stable base. Glass is preferable for studio painting. If we paint outdoors, a plastic container is very practical because it won't break en route. If you go to the country to paint outdoors and you forget your jar, buy a plastic bottle of mineral water, cut it in half, and you will have a ridged jar like the one in the photograph above. (This happened to me once.)

B

WATERCOLOR PAPER

Watercolor paper must have certain characteristics. Not all kinds of paper can be used. Paper that is too shiny will impede the application of color when you need to use an abundance of water. For our future creations we will select paper from the group shown in photograph A. Notice the variety of textures in this fan-shaped sample. Among them we will find the ones we want.

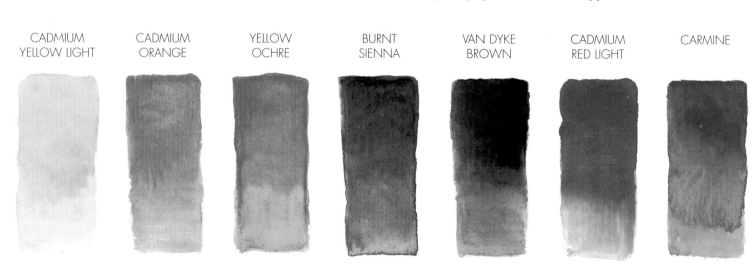

| CADMIUM YELLOW LIGHT | CADMIUM ORANGE | YELLOW OCHRE | BURNT SIENNA | VAN DYKE BROWN | CADMIUM RED LIGHT | CARMINE |

++108

cadmium lemon ++212
jaune de cadmium citron
amarillo de cadmio limón (azo)

cadmium yellow light ++213
jaune de cadmium clair
amarillo cadmio claro (azo)

+238 gamboge
gomme-gutte
gomaguta

cadmium yellow deep +215
jaune de cadmium foncé
amarillo de cadmio oscuro (azo)

cadmium orange +216
orange de cadmium
anaranjado de cadmio (azo)

n clair +304
aro (azo)

cadmium red deep +307
rouge de cadmium foncé
rojo de cadmio oscuro

+318

carmine
carmin
carmin

madder lake deep +331
laque de garance foncée
laca de granza oscura

red-violet +545
violet rougeâtre
violeta rojizo

violet ++536
violet
violeta

ue deep ++506
cé
r oscuro

cobalt blue ++512
bleu de cobalt
azul cobalto (ultram.)

cerulean blue ++535
bleu céruléum
azul céruleo (phtalo)

phthalo blue ++570
bleu de phtalo
azul de ftalo

Prussian blue +508
bleu de prusse
azul de prusia

turquoise blue ++522
bleu turquoise
azul turquesa

green ++617
âtre
arillento

permanent green light ++618
vert permanent clair
verde permanente claro

emerald green ++615
vert paul véronèse
verde paolo veronés

viridian ++616
vert émeraude
verde esmeralda

Hooker's green deep ++645
vert hooker foncé
verde hooker oscuro

sap green ++623
vert de vessie
verde vejiga

green
olive
e oliva

+620

yellow ochre
ocre jaune
ocre amarillo

raw sienna ++234
terre de sienne naturelle
tierra de siena natural

raw umber ++408
terre d'ombre naturelle
tierra sombra natural

sepia ++416
sépia
sepia (modern)

Payne's grey ++708
gris de payne
gris payne

ght oxide red ++339
ouge anglais
ojo inglés

+227

burnt sienna ++411
terre de sienne brûlée
tierra de siena tostada

burnt umber ++409
terre d'ombre brûlée
tierra sombra tostado

Van Dyke brown ++403
brun van dyck
pardo van dyck

indigo ++533
indigo
indigo (modern)

ivory black ++701
noir d'ivoire
negro marfil

STABILITY OF COLORS

On their color charts, the principal brands of watercolors indicate the paint's stability and its tolerance to light. Be careful of the light because not all paints have the same tolerance levels!

If a watercolor already framed and hanging on the wall is exposed to the sun every day, it will fade after a while.

Many colors guarantee a tolerance to light but not to direct sunlight.

COLOR CHART

Most of the manufacturers offer a color chart like the one shown here, with an infinite range of colors, most of which are seldom used by professional watercolorists. Anywhere from twelve to fourteen colors is sufficient. In order to get a wide range, all you have to do is add a specific color (madder lake deep, black, Payne's gray, etc.) according to your taste.

RECOMMENDED COLORS

My recommendation comes from the selection I have made slowly over many years of painting. It consists of fourteen colors: cadmium yellow light; cadmium orange; yellow ochre, burnt sienna, Van Dyke brown, cadmium red light, carmine, yellow green, olive green, sap green, cobalt blue, ultramarine blue, cerulean blue and indigo. I'm not too fond of Payne's gray because with a mixture of burnt sienna, Van Dyke brown, and any of the blues, you can get a great variety of grays, and with the Van Dyke brown and indigo, you can get a very intense black.

| YELLOWISH GREEN | OLIVE GREEN | SAP GREEN | COBALT BLUE | ULTRAMARINE BLUE | CERULEAN BLUE | INDIGO |

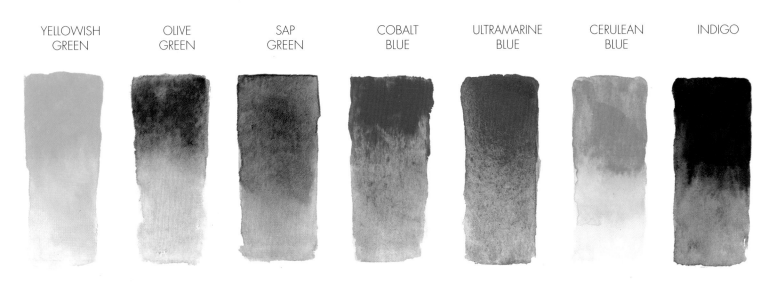

WATERCOLOR TECHNIQUE

*T*he gradation of wet colors is an exercise I would recommend. One of the most important elements of watercolor technique is knowing how to control the water. Also, while the color is wet, you can reinforce, blend, remove, etc. With a sponge or a large brush, dampen the area to be painted (remember—dampen, not wet).
Take a flat brush and fill it with color; from left to right, paint across the paper, blending the brushstrokes, using less color each time until you get almost white.

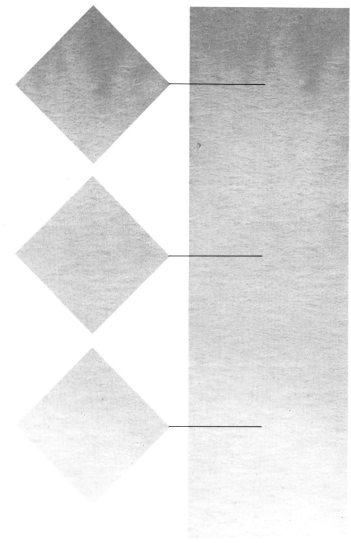

CONVERTING ONE COLOR INTO VARIOUS TONES

In this gradation, three different fragments of the painted area show very clearly how, by simply adding water, we can change one blue into three blues. If we apply this process to all of our washes, we will obtain an endless number of colors.

MIXING COLORS TO GET TRANSPARENT EFFECTS

Watercolor can be mixed on a palette to obtain the desired color. In addition, the transparent quality of watercolor makes it possible to create a range of color effects by layering a wash over a wash of a different color.

LIFTING OUT WET COLOR

There is nothing easier. If you need to lift out wet color in order to lighten an area of a painting, take a clean, dry brush (if possible a synthetic fiber flat brush for its hardness) and draw it across the area you want to lighten. Clean the brush again and draw it across a second time until that part of the paper is completely white.

Try to paint a sphere full of intense color. Before it dries, apply the slightly damp flat brush to the zone you want to work. Turning it will create a white highlight that will give the object volume.

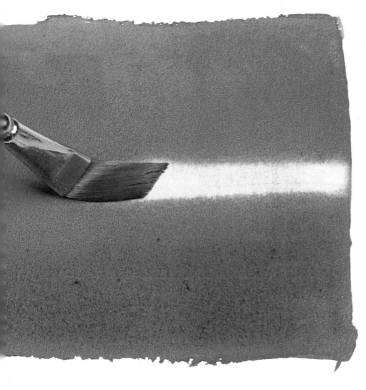

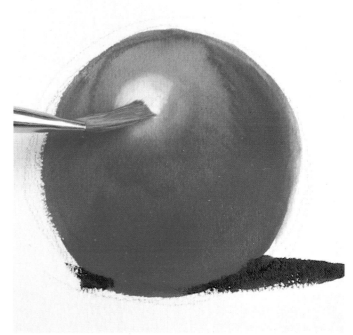

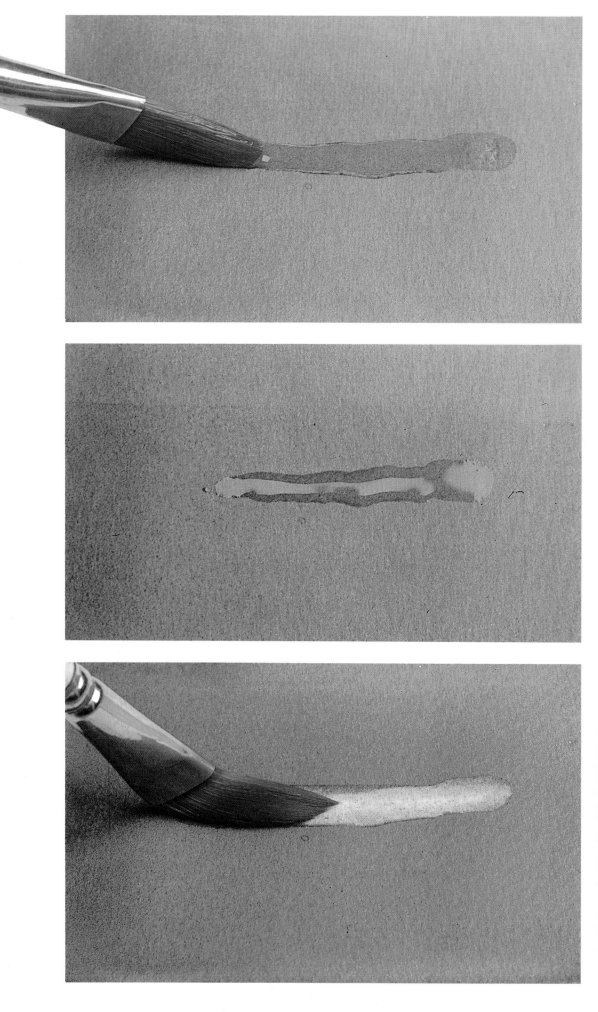

LIFTING OUT DRIED COLOR

If we need to lighten an area where the paint has already dried, we apply a wet brush over this area in such a way that the color becomes soaked with water for a few seconds. Soak up the water with a clean synthetic flat brush, trying in this first attempt to remove almost all the color. Rinse the brush again and, while the paper is slightly damp, go over it again. This time we will get a very neat white. If not, repeat the second operation and this time you're sure to get a totally clean area.

WATERCOLOR CAN'T BE CORRECTED

How many times have you heard watercolorists say that! It's not true. With control and good materials, it can usually be done, especially if the paper is of good quality. If not, as soon as you try to correct an area, the paper will be affected. Watch and see how we correct our mistakes.

MIXING TWO OR THREE COLORS

Try mixing two colors on dry paper. First, stroke on the lighter color, covering a large part of the paper. Add the darker color in the area where you want to blend the colors, drawing the brush quickly over the area where you want the colors to blend, and direct more paint towards the dark area. When the mixture dries, we will paint over it, always using fairly dry brushstrokes without blending them too much or the previous color will be altered.

In the illustration at the bottom of the page we see a gradation, this time with three colors in cylindrical shapes; a light, a dark, and a medium tone. This is how you get a slightly rounded effect. Practice this without getting discouraged. When you begin to master the technique, then you can paint.

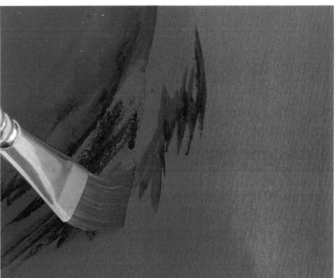

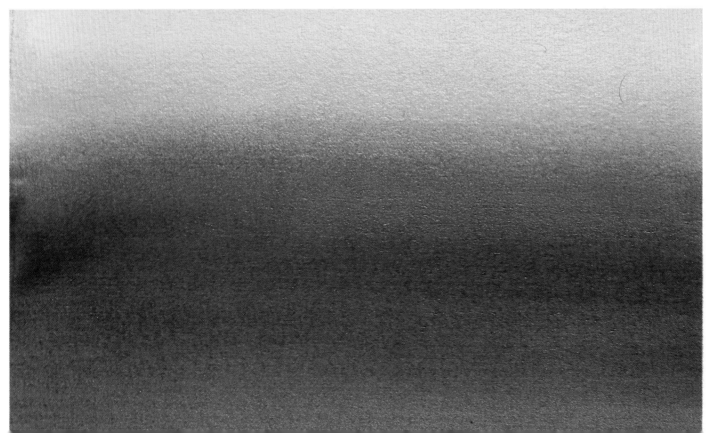

HOW MUCH WATER?

In this exercise we will explain how to solve one of the most common problems that anyone beginning to paint with watercolors will encounter—deciding on the amount of water to use and how wet to make the paper. Both must be controlled or the work may buckle, thus creating more problems to discourage a beginning painter. Keep your courage up!

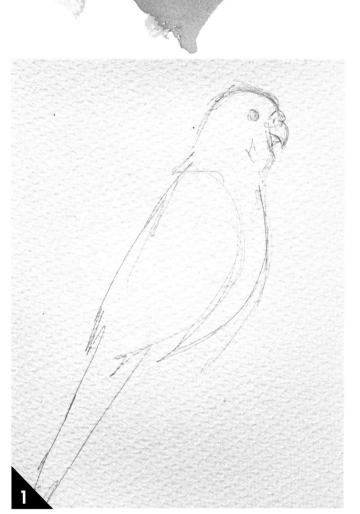

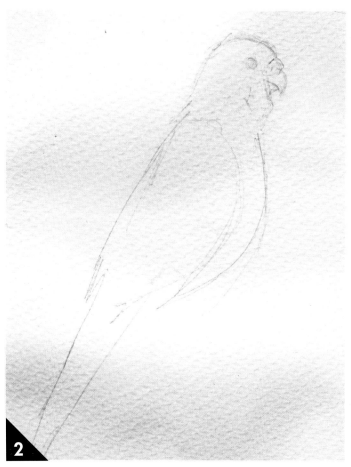

1 We have drawn a parakeet with very concise lines. All we have to do now is make the bird more artistic.

2 We have wet the paper. On many occasions this is a good idea because it cleans the paper of its coating and eraser crumbs. This time we put on too much water. As a result, the paper is wrinkled.

3 We begin to paint too soon, with the paper still very wet, instead of damp, as it should be. This means that the color will run outside the designated lines.

4 We take a small, natural sponge and, before the paper begins to dry, (the color is already diluted in the water), we mop up the area where we have painted, gently, without pressing. The paper is almost clean.

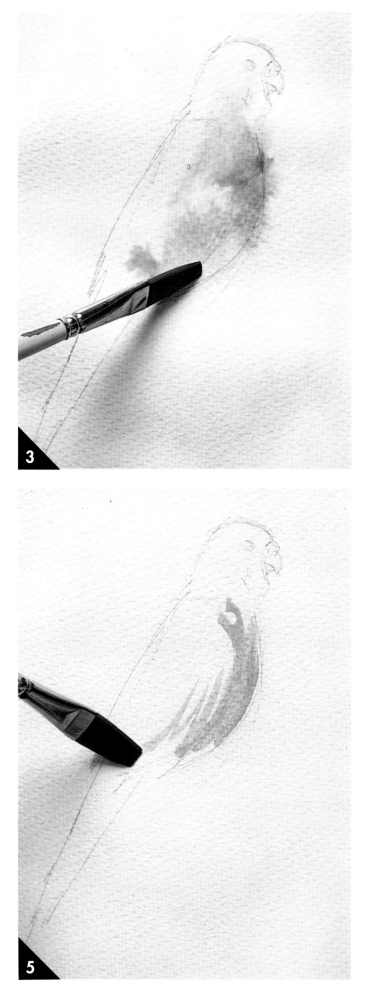

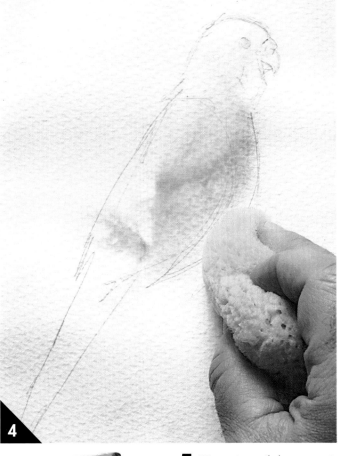

5 We wait until the paper is completely dry. When it is almost smooth, we begin to paint again. We can see that what seemed to be a problem has been solved with patience and care.

BASIC SKETCHES

*O*n these two pages, using a blue pencil, I have drawn sketches of most of the animals pictured. Here you can see how easy it is to draw. The majority of the sketches, as in the case of the birds, are drawn with a circle and an oval. If we add details carefully from the very beginning, we will have our first sketches.

TWO CIRCLES

If we draw two circles we almost have the shape of the heads. In the case of the parakeet, for example, even the beak is included. To complete the sketch of the goldfinch's head, you merely indicate the small depression at the base of the beak, place the eye in the circle, and add the beak as a triangle.

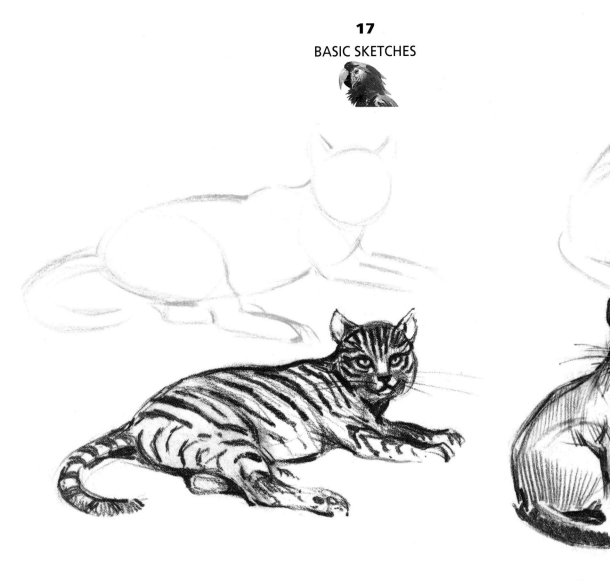

GEOMETRIC SHAPES

With the help of a few added lines to complete the form, cats and dogs can also be drawn using geometric shapes. Follow this dog's head step by step. After the initial circle, place the triangle of the eye, the shapes of the ears and the nose. Next, and with only one color, put on the finishing touches until you get it. Did you do it? Good!

PAINTING A PARAKEET

*W*e'll begin the exercises with a parakeet because it's the most placid and calm of all the animals we're going to paint in this book. First, notice that the blue in the birds in the photograph has only a few mixtures of color. This makes our first exercise easier, as you go step by step from your sketch to the last brushstrokes. Good luck!

1 It's not difficult to find one or two parakeets like the ones in the photograph. Many people have them as pets at home, which means they can be studied in a small space. Once you decide on a pose, you must get to know their behavior and colors. With a well sharpened pencil, in a schematic way, draw the parakeet's outline.

MATERIALS

- Hot-pressed paper
- 2B or 3B soft lead pencil
- Round number 4 and 14 sable brushes
- Number 14 flat brush of synthetic fiber, 1" wide
- Natural sponge
- Tube colors:
 Cadmium yellow
 Cadmium yellow orange
 Vermilion
 Carmine
 Yellow ochre
 Raw sienna
 Van Dyke brown
 Cobalt blue
 Ultramarine blue
 Cerulean blue
 Indigo
- Metal watercolor box with compartments for colors
- Rags, paper towels, or an old towel

You can paint the background with yellow ochre and a gray that is a mixture of burnt sienna and cobalt blue, applied with the flat brush of synthetic fiber and a lot of water. We don't worry about the shape; what we want to do is to contrast the parakeet's blues and let the white areas stand out.

The dark strokes suggesting wing feathers are the result of a blue indigo, burnt sienna, and ultramarine mixture. Brush-strokes are applied with different amounts of water: in this way you get a gradation of different intensities, the most intense are applied with very little water.

Intensifying the previously applied gray with some ultra-marine blue, we paint the bird's perch and the upper part of his wing very spontaneously. In this way we paint over some of the reserved white area and add depth to the bird's body.

The tail has been painted very freely with cerulean blue, ultra-marine blue, and blue indigo, and we can permit ourselves the luxury of making a mistake or two. Paint decisively and spontaneously, without too much water, which makes it easier to draw the brush across the paper and make these dry brushstrokes.

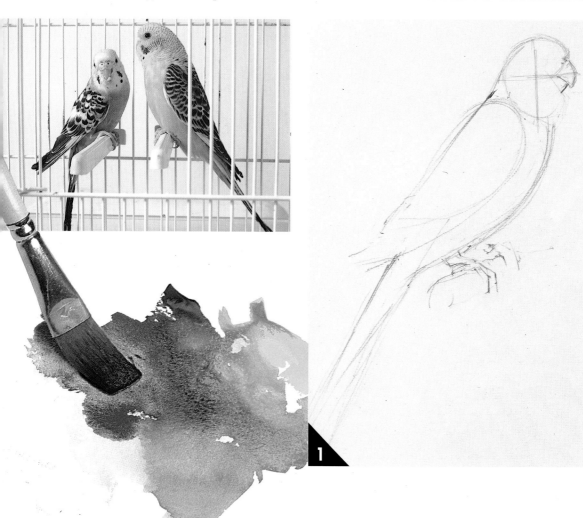

The head has been done with tones of gray. Pay attention to the eye, as it is very important to leave the white highlight there to give the bird its vivacious expression and sense of alertness. The white area should not occupy too large a surface, or it will lose the effect we're trying to achieve.

The parakeet's beard is done with grays, and we have added water to the bird's characteristic dark markings. Next, a dry synthetic brush has been drawn over the paper, lifting out the color, to give the feathers a soft look.

We have painted the blue part of the bird's body by letting the color run in a spontaneous way. We finish with cerulean blue and ultramarine blue brushstrokes, using very little water and hardly blending at all, to give spontaneity, one of the watercolor's most important qualities.

Finally, the feet have been painted with a very diluted carmine, finishing with a mixture of burnt sienna and vermilion, left in a slightly impressionistic, spontaneous state. In this way we break the monotony of the blues in the body with the orange beak, the carmine in the feet, and the grayish yellow in the background.

2 Once the shape of the bird is drawn, we begin to make details. You can see the work we have done on the head, the eye, the characteristic beak, the beard, the feet, and how we lightly suggest the feathers of the wings and the tail.

3 Before applying the color, we wet the parakeet's body with the flat brush. (Remember: Be careful not to let the paper get too wet.)

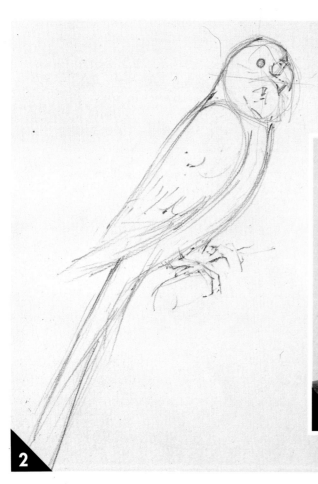

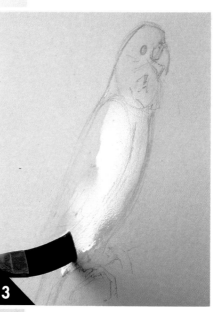

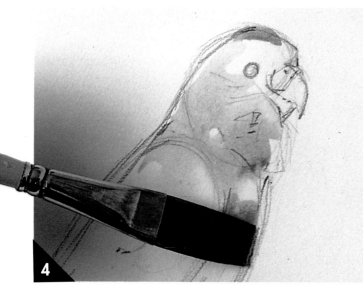

4 Immediately afterwards, with the same flat brush, we begin to paint the bird's head and part of the body with a mixture of burnt sienna and cobalt blue, which makes a warm gray.

5 Taking advantage of the wet paper, we layer cobalt blue over the gray on the body, and this gives us a shaded blue.

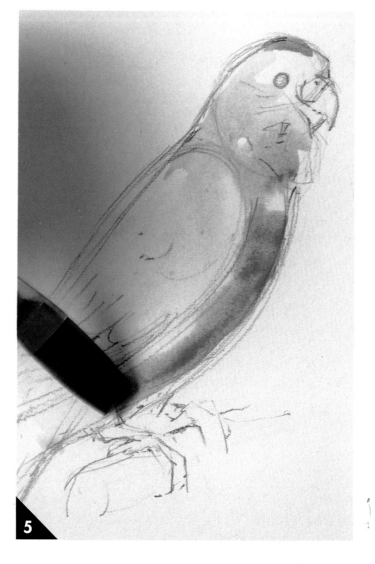

6 In these first few moments, notice how we keep the color soft and loose as the subject is given form and volume. We will try to keep this loose quality so that the painting does not become overworked.

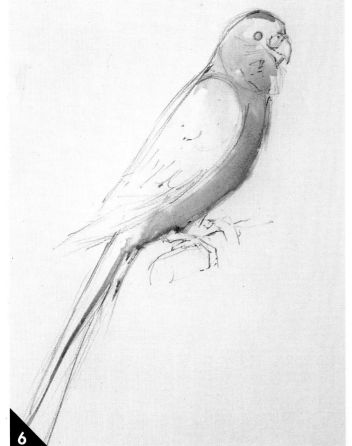

6

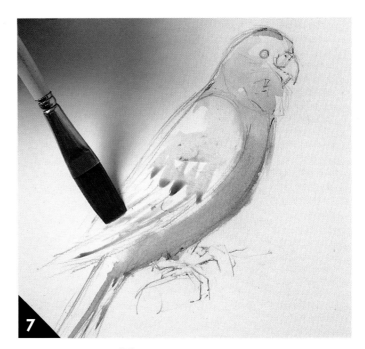

7

8 Between the head and the upper part of the wing, you see the strokes we applied to get those first contrasts between the lightest and most intense areas of the painting. We change to a number 10 round sable brush and paint the parakeet's beak with cadmium orange.

7 With the same gray as before and with a flat synthetic fiber brush, we begin shaping the wing feathers with a soft wash, which will be a base for additional washes.

8

THE PRESSURE OF THE PENCIL

When you do the drawing, be sure not to press too hard with the pencil, so that the line won't be noticeable on the paper if you need to erase and change something that doesn't seem quite right. Remember, watercolor is a completely transparent pictorial process.

9 With the first washes applied, we are beginning to develop the parakeet's shape. We darken the tip and the underside of the beak with burnt sienna to create depth. The part of the body next to the feet we darken with a mixture of cerulean and cobalt blue. Toward the tail we add ultra-marine and darken that area even more. Next, with a very diluted carmine, we paint the feet.

10 With a mixture of the same gray, slightly more intense, we paint the very delicate striped area in the parakeet's head, around the eye, and part of the beard.

11 When the head is completely dry, with a mixture of Van Dyke brown and indigo, which gives us an intense black, we paint the eye *very carefully* to avoid touching the white area we left for the highlight. Use a round number 4 brush.

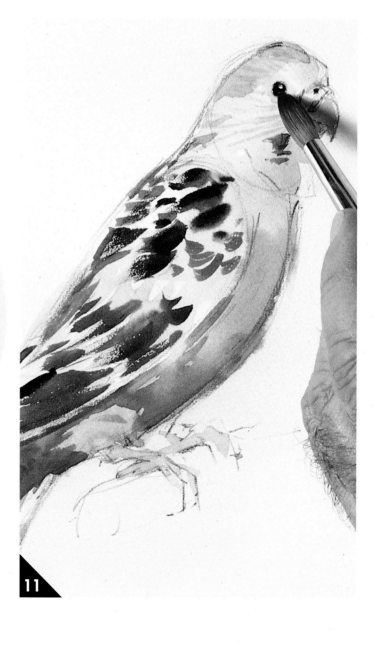

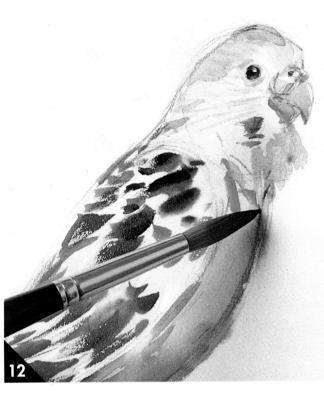

12 With cerulean blue we continue defining the line of demarcation between the head and the body. We intensify the grays in the top of the head and the beard, finishing the upper part of the beak with its characteristic hole.

13 When it's convenient, we can stop and contemplate our watercolor since it is almost finished. The color used to paint the eye is now used in brushstrokes on the dark part of the wings. To keep the same intensity of hue, we add very little water. We have added some brushstrokes to the feet with carmine and burnt sienna.

HOW TO HOLD THE BRUSH

When painting, try not to grip the brush close to the metal band, as your hand will lose mobility and agility. If you get used to holding the brush more or less in the middle you will tire less and have more control; you will be handling the brush the way a fencer handles the sword.

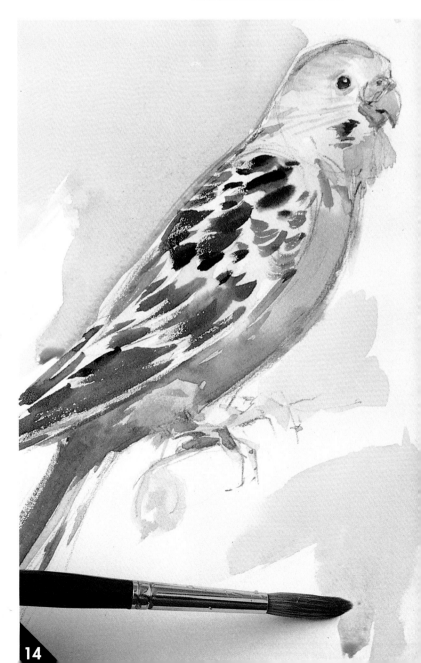

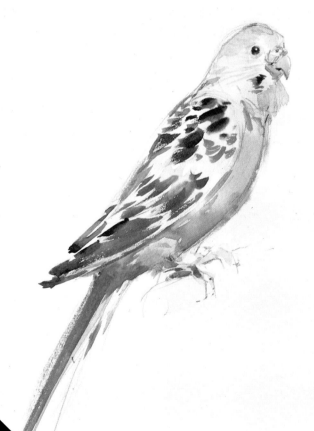

14 With a diluted mixture of yellow ochre and gray, we paint the irregular background, leaving the paper white to suggest the parakeet's perch. We then add some touches of pale gray on the end to indicate the form of the perch in the cage.

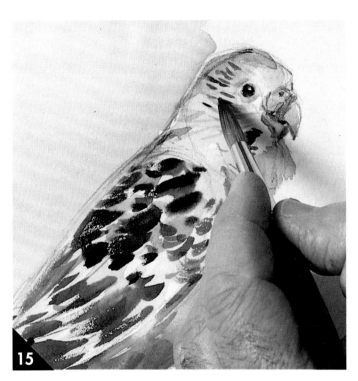

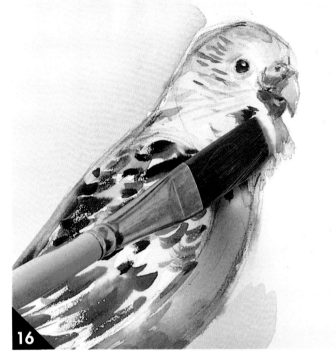

15 With a mixture of indigo and Van Dyke brown, we have painted the eye and the wing feathers. We draw a few dark lines on the striped head, but more diluted now, so they aren't so black.

16 We are nearly done. With a damp synthetic brush, we lift out some of the gray from the beard, creating more light areas. We can take advantage of these moments to make some quick sketches of the parakeet, an exercise that will help us capture the bird's varied movements.

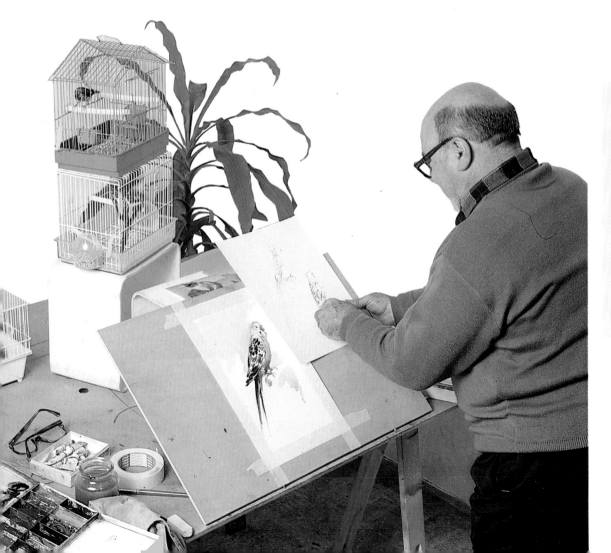

SKETCHES

Whenever you have the opportunity, make sketches without erasing, directly from your model. Try to capture the animal as it moves around by drawing its movements, Don't try to put in details, which would ruin the spontaneity and liveliness. Sketching is a stimulating exercise, and it will loosen you up. If you don't achieve exactly what you want right from the start, have patience, persist, and eventually it will work out.

17 There is very little left to do; with a few brushstrokes of carmine and burnt sienna we add final touches to the bird's feet. At this point, leave them slightly unfinished to give an air of spontaneity and freshness.

DRAWING AND PAINTING A CAT

*O*n this occasion I have chosen a Siamese, since it is easier to paint than a tiger cat. The skittish model's stripes increase the difficulty we are having. If we don't inspire his trust, which is difficult to do with cats, he will hide. Therefore, it is advisable to observe him carefully for a while. When he chooses a pose we like, we begin to sketch him rapidly. We will probably choose a pose when he is resting.

MATERIALS

- 11" × 15" (25 × 35 cm) cold-pressed 50% cotton Fabriano watercolor paper (22" × 30" sheet cut in quarters)
- 3B soft pencil
- Round number 2, 4, and 10 sable brushes
- A flat brush of synthetic fiber, 1¼"–1½" wide
- Natural sponge
- Tube colors:
 Cadmium yellow light
 Cadmium yellow
 Cadmium orange
 Vermilion
 Burnt sienna
 Van Dyke brown
 Cerulean blue
 Cobalt blue
 Ultramarine blue
 Indigo
- Rags, an old towel or paper towels
- A metal watercolor box with compartments

1 With a 3B soft pencil we sketch the form of the cat. It's advisable not to press hard on the pencil, because if we need to erase, heavy pressure will leave a mark on the paper.

2 Now that we are sure of our original sketch, we go over the drawing, adding the characteristic shapes of the eyes, nose, mouth, and ears with more confidence. Then we carefully draw the position of the feet.

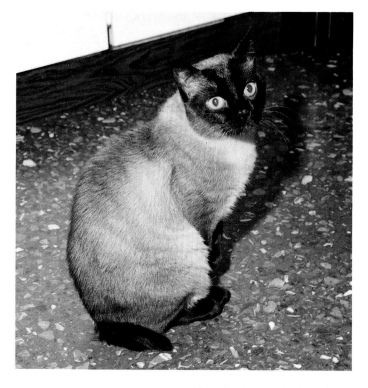

The background has been painted a neutral gray. This is a pale wash of cobalt with a small amount of burnt sienna. The result is a cool tint that contrasts well with the warm tones of the cat's body.

The area of brightest color on the cat is painted with burnt sienna, ochre, and some Van Dyke brown on damp paper. We use this mixture painting a semicircular stripe that we stroke toward the center. Without trying too hard, we give the impression of fur.

With a mixture of Van Dyke brown and indigo, we paint the area of the tail and the hind legs of the cat. This combination of colors produces an intense black that offers a range of rich darks; sometimes there is a blue tone to the black, and at other times the tone may appear redder.

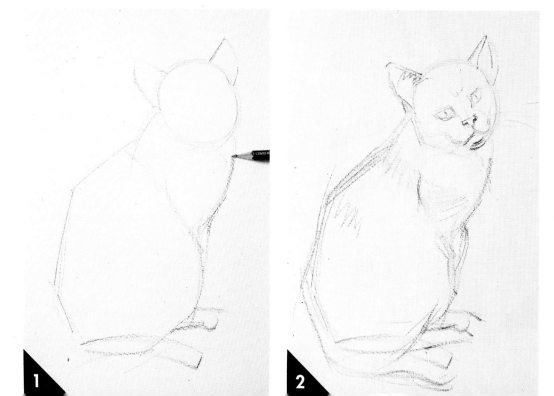

1

2

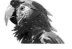

3 In this exercise we fill in the entire background with a pale value of cobalt blue and burnt sienna, painting very wet with a flat synthetic brush.

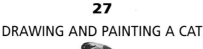

The head of the Siamese cat is painted in a mixture of yellow ochre, burnt sienna, Van Dyke brown, and indigo. As we worked, we kept the dark value of the head in mind, letting the lighter tones show through. It is important not to overwork the nose and mouth and other dark areas in the face in order to retain a feeling freshness.

The eyes, which give the painting its vivacity, should always seem to be looking at you. Here they are painted with a very diluted cerulean blue, and an area of white paper has been left for highlights. Once dry, with the same mixture of black that was used to paint the tail, we paint the retina and the dark line that surrounds the eyes. (The cat's eyes are really blue; in the photograph they appear red as a result of the flash.)

Also, with the same black and very little water, paint the small nose, and the dark points in the whiskers and the mouth as well. Scratch out the paper at the base of the whiskers with a razor blade and you'll get some tiny highlights.

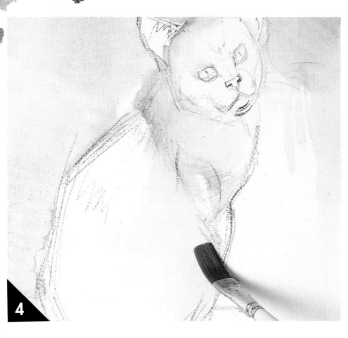

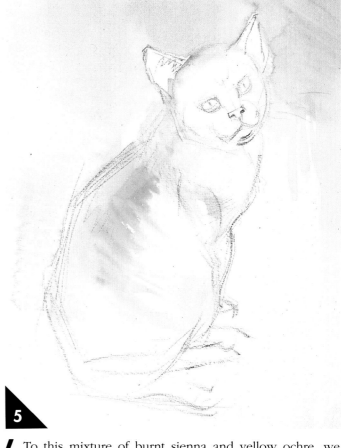

4 Next, with a mixture of yellow ochre and burnt sienna, and plenty of water, we use the flat brush to paint the color over the lightest parts of the cat's fur, leaving some areas damp.

5 Now, more burnt sienna is added to the previous mixture, with very little water. Blend it lightly and use this color to begin to develop the rounded form of the cat.

6 To this mixture of burnt sienna and yellow ochre, we now add ultramarine blue. This gives us a cooler tone of sienna, which is now stroked on the cat's lower back. Make sure that the brushstrokes follow the form of the cat.

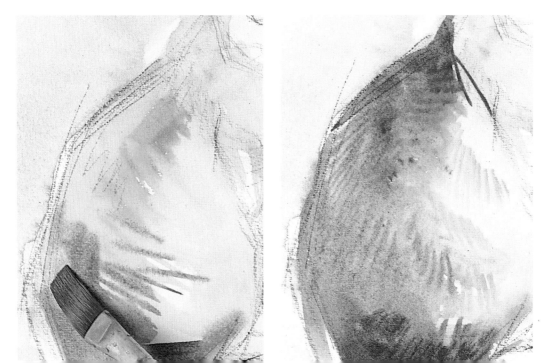

7 With the same flat brush and Van Dyke brown, we darken the cat's lower back. This gives a feeling of solidarity to the form of the animal. These last brush-

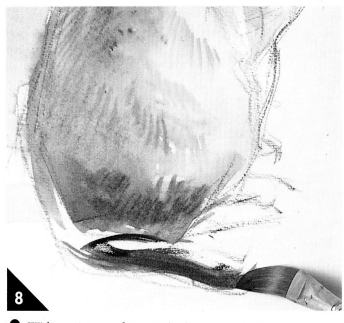

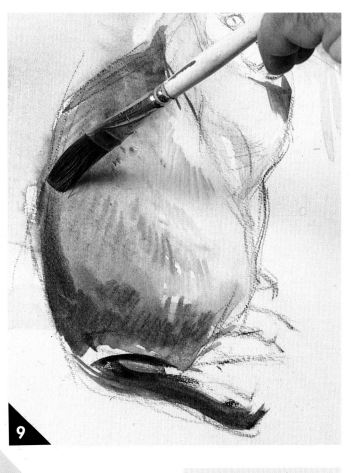

8 With a mixture of Van Dyke brown and ultramarine, very freely and loosely paint the shape of the tail, giving it a sense of movement.

9 With a brushstroke of the same tone used to paint the tail, we darken the lower area of the cat's back, directing the brush upward and diluting the color in the upper area.

WHITE AREAS

The color white is the result of leaving the white paper unpainted. For this reason, you should plan where you want white areas to be in your composition and then carefully avoid painting over them. Another way to add white areas to a painting is to lift out color with a clean, wet, flat brush, brushing over the painted area to be removed. To lift out a large area, you can use a natural sponge.

10 Finally, we get to the cat's head. With Van Dyke brown and some cobalt blue, take the flat brush and stroke around the eyes, carefully leaving the eyes white.

11 We continue with the same flat brush, painting the entire front part of the head, taking care to paint around the eyes while keeping the white areas clean. The cat's final expression will depend largely on the eyes' transparency.

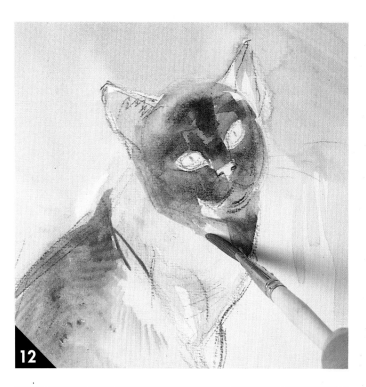

12 With a mixture of burnt sienna and yellow ochre we paint the cat's head and the shadow under his mouth. With the same color, very diluted, we paint the ears. Notice how this color blends with the previous dark value and gives the head a three-dimensional quality.

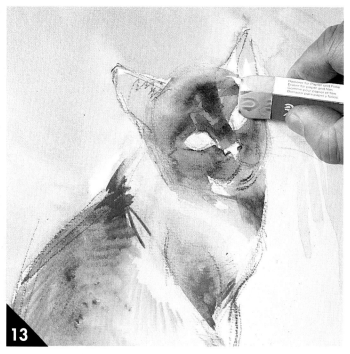

13 Even though we were careful with the pencil, we erase the lines before painting the eyes. Be sure the area around the eyes is very dry; if not, the paper will tear.

14 With a round sable brush we paint the eyes using cerulean blue, keeping the white highlights of the eye. Let the paint dry before continuing.

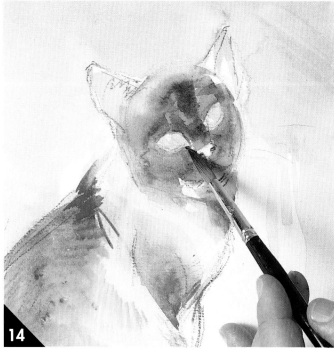

CLEANING THE PAPER

If, while you have been erasing and drawing, you noticed that the paper was slick, erase the dirtiest parts. If the paper is cold pressed or hot pressed, sprinkle some talcum powder over it to help remove the slick coating. Next, with a dry brush, remove the powder.

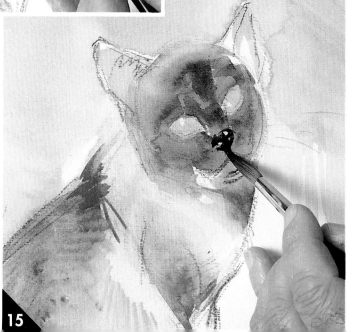

15 Another characteristic part of the cat is the nose. With indigo and Van Dyke brown and a small amount of water, we get an intense black. We leave an area of the paper white on the upper part of the nose to make it appear slightly moist.

16 With the same color used to paint the nose, we model the darkest areas of the cat's face, which emphasizes the glowing eyes of the animal. Brushstrokes are kept loose and spontaneous.

17 Using the same tone, we begin to model the ears. We darken the top of the shoulder and the top of the mouth. We are getting close to the cat's most expressive area.

18 We continue and finish the ears and the lower part of the cat's mouth with the same tone and the same brush. Inside the ears, we leave a light area, darkening only the tops.

19 With a number 4 sable brush and a mixture of burnt sienna, indigo, and Van Dyke brown, we use very little water and take great care to paint the inside of the eye and the dark outline around it.

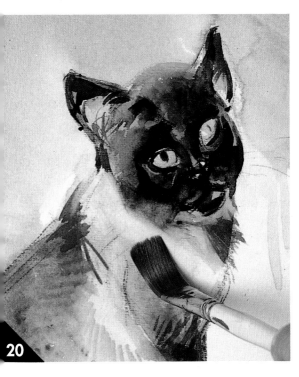

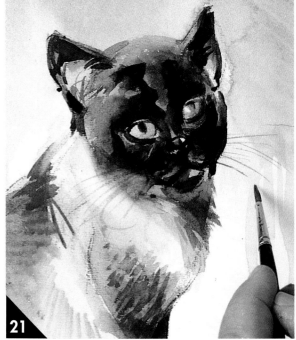

20 It is harder to lift out color from cotton paper, but if we wet the area thoroughly first, we can lighten the area underneath the head. We have also darkened the shoulder area with Van Dyke brown. These are some of the final details.

21 With a number 4 brush, some gray, and plenty of water, we paint the cat's whiskers very loosely. If you don't get the result you want, clean the area off by wiping it very softly with the sponge. Be careful not to remove the paint you applied previously. If you are persistent, you'll get the whiskers the way you want them.

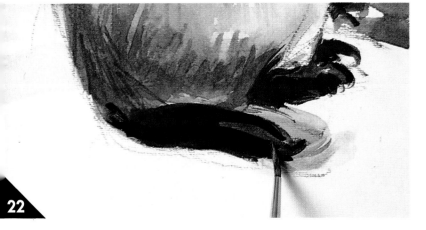

22 With indigo and very little water, we paint the last lines in the tail, the hind paws, and the edge of the front paw.

23 After finishing the other eye, the only thing left to do is to create some small white highlights on the cat's whiskers by scraping the paper with a razor blade.

WETTING THE PAPER

If you are painting in the summer or in a very hot place, you should wet the whole paper first so that it doesn't get stiff. If we want to paint a watercolor in the winter or when it's cold, it would be better to dampen only certain areas of the painting because there is nothing more frustrating than not being able to control the paint because of too much water.

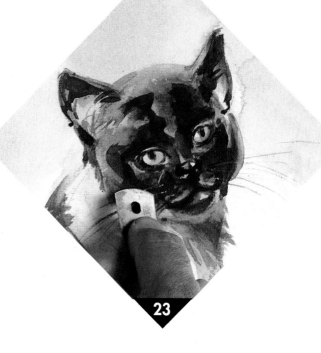

24 We darken the left side of the gray background, and, starting with the front paw, we paint a long gray stroke to give the impression of a shadow. In this way the cat is well-grounded within the painting we have just finished.

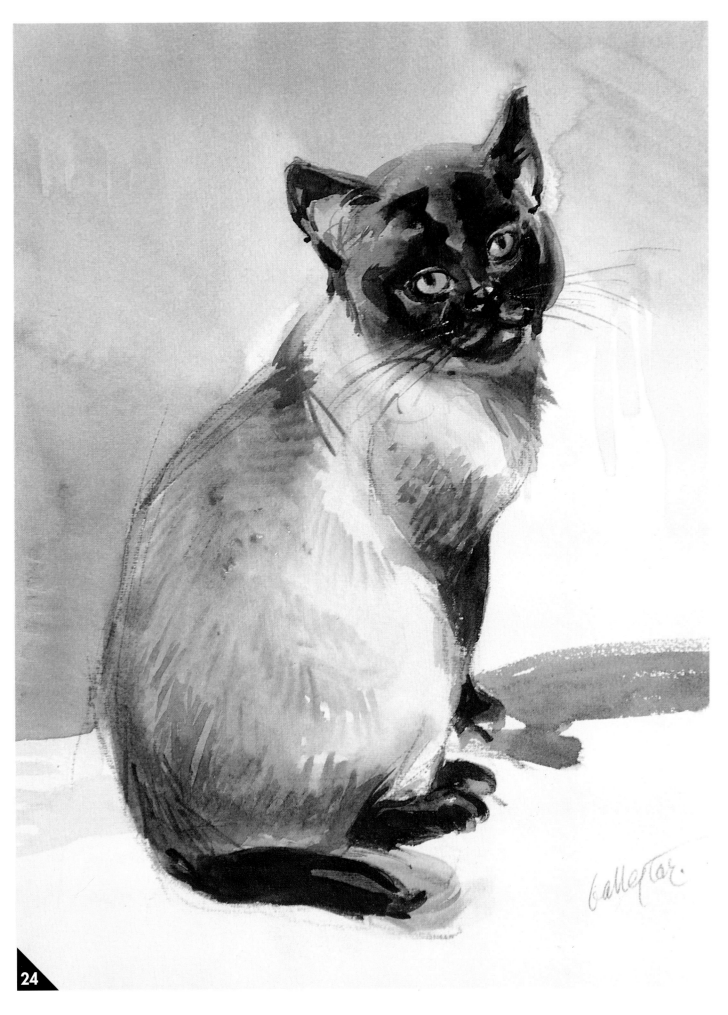

24

PAINTING A GERMAN SHEPHERD

*T*he bigger the animal is, the more difficult it is to paint him because he needs more space to move around. As in the case of the cat, it is advisable to find a moment when the dog is resting, as in this photograph. If he is lying on the floor, sometimes his feet are hidden, and if you don't have much experience painting, the final result can be quite unusual! Let's get ready to make a good painting.

MATERIALS

- 11" × 15" (24 × 33 cm) cold-pressed 50% cotton watercolor paper
- 2B soft pencil
- Numbers 2, 4, and 10 sable or ox-hair brushes
- Synthetic fiber flat brush ¾" or 1¼" wide
- Tube colors:
 Cadmium yellow light
 Cadmium orange light
 Yellow ochre
 Burnt sienna
 Van Dyke brown
 Cadmium red light
 Carmine
 Yellowish green
 Sap green
 Cobalt blue
 Ultramarine blue
 Cerulean blue
 Indigo
- Rags or paper towels
- Metal watercolor box with compartments for colors

With yellow ochre and some cadmium orange, almost all of the light areas of the dog have been painted and later reinforced with burnt sienna, applied with less water to increase the intensity of the color.

The dark lines of the body are a result of a mixture of Van Dyke brown and indigo. One color or the other can dominate, depending on what you want. Blue dominates in the dog's body and the brown has more highlights; in this way, the darks are less monotonous and the painting is enriched with subtle variations of color.

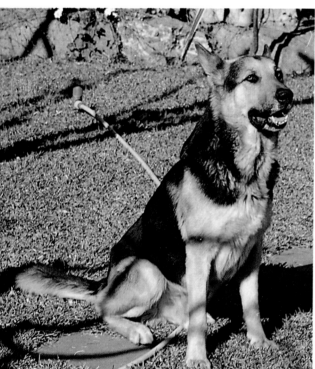

With yellowish green and yellow ochre you get a neutral color that doesn't detract from the dog and can be applied very freely behind the animal, using plenty of water.

1 As in the previous exercises, make the first lines of the general drawing, erasing as little as possible, and go over the lines where you make a mistake. Once you are sure of your sketch, define the lines more and check to see that the drawing's proportions correspond to those of the dog we are going to paint.

The dog's shadow is painted in a very bluish gray. It's the indigo dominating in the burnt sienna and indigo mix that makes this tone cool so it complements the warm color of the paws.

The inside of the eyes is painted with cadmium orange, which has been left very transparent. Once it is dry, you can use the mixture of colors that was used in the darkest areas of the animal to paint the area around the eye and the almost black point inside the eye. This gives the dog his expressive look.

The tongue's color is a different shade. You can get it by using a very diluted cadmium red, letting it dry, and applying some touches of carmine which also gives it shape and suggests shadows.

The whole front part of the dog's chest has been left white, applying only strokes of light gray washes, which are mixtures of sienna and blue, sometimes letting the sienna dominate and other times the blue, achieving a rich range of whites.

Yellow was added to the greenish background to give it highlights. And with yellowish green we create more of a contrast, which enriches and adds light to the overall painting.

2 The drawing is finished. Before beginning to paint, it is a good idea to correct anything and leave the sketch as perfect as possible, since watercolors done on paper with a cotton content are very difficult to correct. Once we have checked our drawing to make sure it is the best we can do, we can start painting.

3 With yellow ochre, some cadmium orange, and plenty of water, we shape the head with the first brushstrokes. A round brush will permit us to follow the outlines better.

4 To the previous mixture we add a small quantity of ultramarine blue. We paint the light areas delicately, keeping some areas of the paper white.

5 We use the same tone we applied to the head to complement the light areas. Using more water, we paint the dog's front paws, leaving their color less intense than the rest of the dog's body.

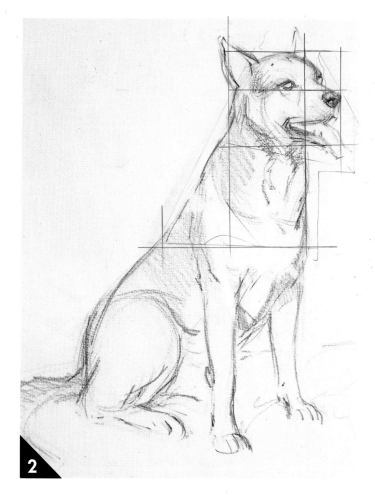

2

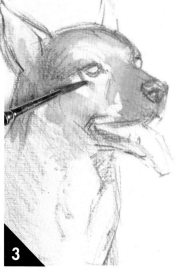

3

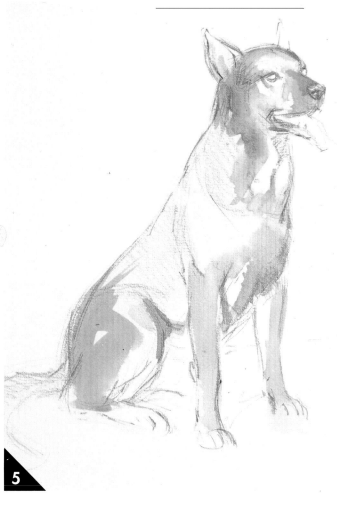

5

MIXING COLORS

You must practice mixing colors, since it's this technique and your control of the medium that will be responsible for your success with watercolor. Two colors in equal parts will give you a tone; adding more or less of one color will give you another color. The one with the greatest amount of color will dominate. We can go through the entire range of our palette and achieve a wide range of secondary and tertiary colors.

4

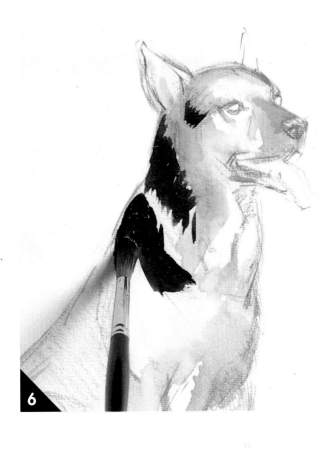

6 Once we have painted the medium and light tones, it's advisable to paint a few brushstrokes in a darker tone. In this way you can get the three essential values. This will be a big help when you need intermediate values.

7 These dark brushstrokes are a result of the indigo and Van Dyke brown mixture. It gives a rich dark tone that we can vary from one color to the other. The upper part of the dog is bluish, and the bottom colors are almost brownish.

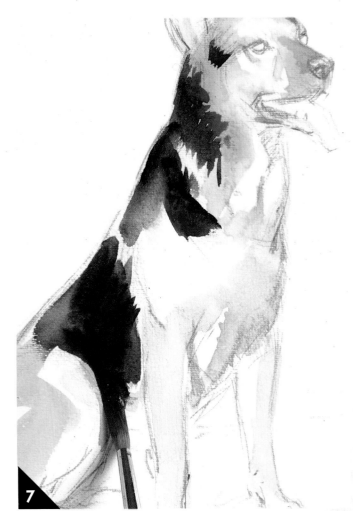

8 With a reddish tone, which is a result of the burnt sienna and cadmium red mixture, we paint the edge of the dark area of the dog's neck and the line that divides the lightest part of his fur from the area under his mouth.

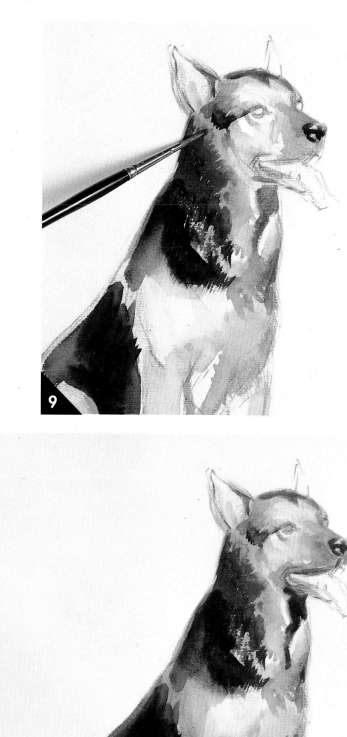

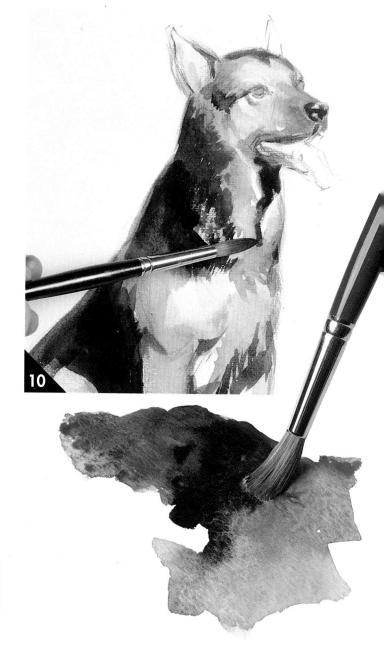

9 With the same black that we have just used, we begin to construct the dark areas of the dog's head, silhouetting the upper part of the eyes, the outline of the head, the nose, and the dark area that starts by the eye and continues up towards the ear.

10 With the same tone now diluted, we reinforce the shadow that crosses the lower area of the mouth towards the lightest part of the dog, using wet brushstrokes in the area where the animal's front paws begin.

11 We begin painting the dark parts of the front paws with Van Dyke brown. We add cobalt blue and carry the color between the paws over to the right side of the painting. This positions the dog in the watercolor.

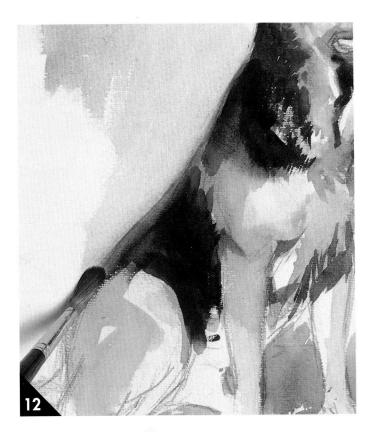

12 By painting the background with yellowish green and yellow ochre, my intention is to complement and unify the rest of the painting, giving it a neutral look, like a garden slightly out of focus.

13 With a number 4 brush, cadmium red, and very diluted carmine, we fill in the tongue. Let it dry, and then using carmine and a little water, make a few brushstrokes to give it shape and shadow.

14 Once the color is dry on the eye's transparent base, we use black and very little water to paint the interior of the eyes and the silhouette around them.

PAINTING DETAILS

You will get used to associating the word *detail* with the minute touch-ups applied at the end of the painting. When we add details in watercolor paintings, it can seem as though we're losing spontaneity. Actually, that's not the case. To add detail is to adjust some areas of our painting, like finishing an eye or the animal's nose without losing the painting's freshness. But don't get too carried away!

15 We have accomplished quite a bit on the dog's upper body. We finished the ears with carmine and Van Dyke brown; then with cadmium red and burnt sienna, we painted the fur around the head, and with a few irregular yellowish green brushstrokes, we filled in the animal's right side.

16 With a fine brush we define the muscles, painting the dark parts of the hind paw as if we are drawing. We do all of this with Van Dyke brown, blended with a very diluted bluish tone.

17 Take advantage of the bluish tone and the Van Dyke brown to make a curved brushstroke for the base of the tail and its shadow.

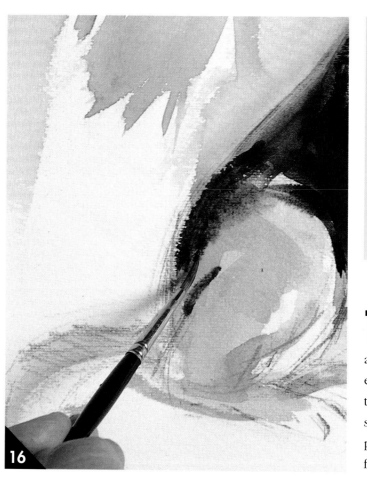

FINISHING A PAINTING

One of the most difficult problems in painting, particularly with watercolor, is to know when the work is finished and to avoid going beyond this point, losing spontaneity and freshness. You also must recognize when a painting is still half-finished and needs more work. Analyze the painting carefully so that you learn to stop at exactly the right moment.

19 There is very little to add; fix a few points around the nose and the eye, darken the shadow on the floor, put a gray brushstroke on the bottom of the paws, and look over the final result.

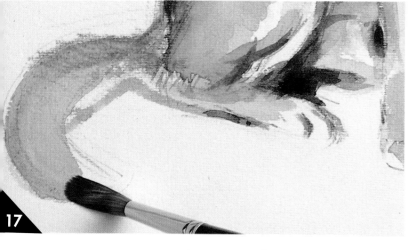

18 Using a black from our mixes, we go over the entire tail we have just painted, using very little water and making vertical brushstrokes to give the impression of thick fur.

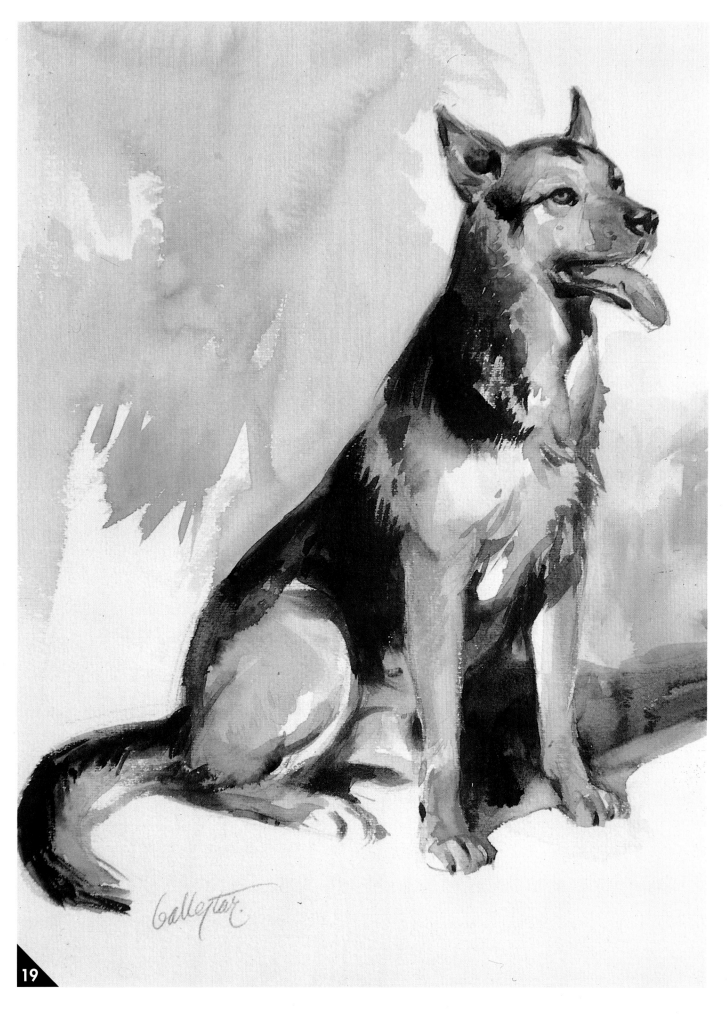

A RED MACAW IN ONLY THREE COLORS

With cadmium lemon yellow, carmine, and ultramarine blue, we will paint a red macaw, a bird that is a perfect subject for this exercise, as his feathers are practically these same colors. We will add a few mixtures of colors to give a range of tones, to enrich them, and to create a sense of form and volume, along with the impression that the bird was painted with more colors than we actually used.

MATERIALS

- 14" × 17" (pad) or 14" × 20" (block) (38 × 46 cm) hot-pressed watercolor paper
- Mechanical pencil with 4B soft lead
- Numbers 2, 4, and 10 round sable brushes
- Synthetic fiber flat brushes ¾" to 1¼" wide
- Tube colors:
 Cadmium lemon yellow
 Carmine
 Ultramarine blue
- A rag, an old towel, or paper towels
- A porcelain plate

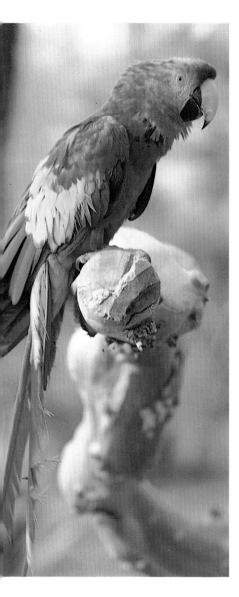

1 We draw the outline of the macaw, as well as lines indicating the direction of the feathers and the position of the eye and the beak. Since the bird's colors are so intense, these pencil lines will be covered and won't show through the finished painting.

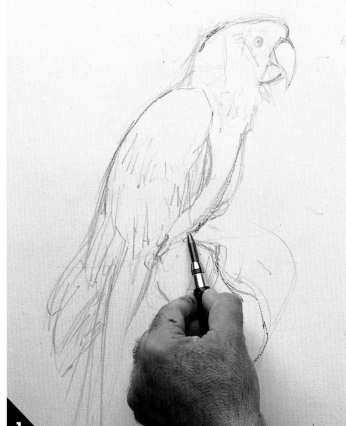

The interior tone of the eye is achieved by mixing cadmium lemon yellow and carmine in equal parts, which gives us an orange tone. Adding a dash of ultramarine blue turns it ochre.

The intense red in the wing is a mixture of cadmium lemon yellow and carmine. We allow the pink underpainting to show through. It is the same color as the red in the wing, but diluted with water.

With the same mixture, very diluted, we add thin strokes over the yellow so that the top yellow part of the feathers remains a pale orange, adding luminosity and volume.

With a mixture of carmine and ultramarine blue we get purple for the feathers. If we want the feathers to be intense and contrasted with the blues in the tail, we should add very little water.

The mixture of three colors in equal parts will make black, which is applied with little water so it is not reduced in value. With this color, paint the indicated area of the beak and the black part of the eye.

Here, a darker value of carmine is achieved by adding a thin glaze of ultramarine blue. This will darken the area without turning the color purple, like the tail.

The trunk on which the macaw is perched is painted a neutral ochre, a mixture of our three basic colors. We vary this color by adding more carmine or more ultramarine.

The background is loosely painted with a mixture of lemon yellow, a small amount of carmine, and just a touch of blue. The yellowish color dominates and complements the rest of the painting.

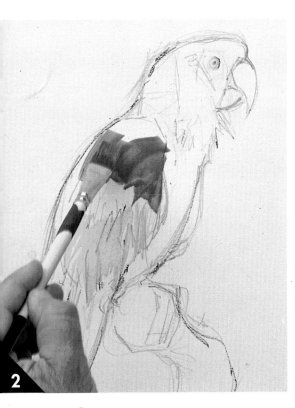

3 Notice how this vermilion wash, which was stroked over the upper part of the wing and the head, begins to define the form of the macaw. Next we begin painting the bird's darkest areas with a slightly diluted carmine.

4 With the same flat synthetic fiber brush and carmine we model part of the head and the bird's wing. Next, we add ultramarine blue and lemon yellow to the carmine to paint a dark tone on the lower part of the wing, with some touches on the neck.

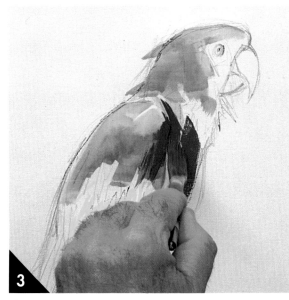

2 We begin painting with the lightest color, cadmium lemon yellow. If we add carmine, we get a light vermilion tone. If we dilute it with enough water, we can use it as a base when we begin painting the macaw's intense reds.

THE CERAMIC PLATE

For this exercise it is suggested that you use a large porcelain plate to arrange the colors as they are in the photograph. This way, the center of the plate can be used for mixing colors. When you want a wash of pure color, dip a wet brush into the clean paint and mix it on the edge of the plate, avoiding the color mixtures in the center.

5 That's it! A few brush-strokes of ultramarine blue. Notice how bright the color is and how well it complements the other three colors! If you add a very small quantity of carmine to it, it will tone down and enrich the color (we will have two different blues).

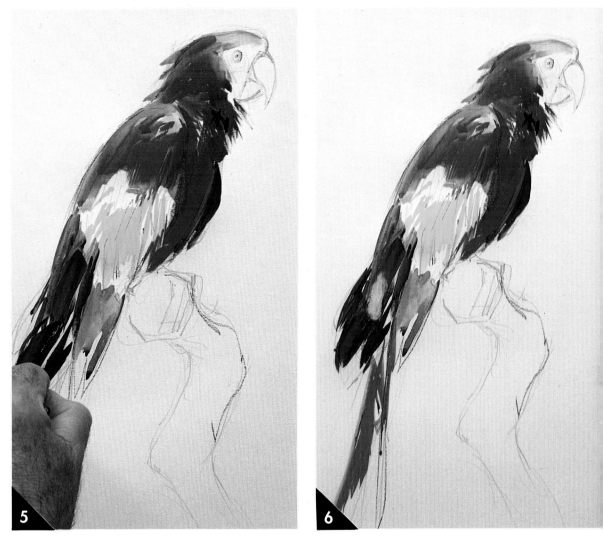

6 Now we have the red macaw's principal colors. The final strokes to the macaw's body are made with a mixture of ultramarine blue and carmine, only slightly diluted to keep the color intense. To this mixture we add lemon yellow and water to paint the bird's longest feathers.

7 Be careful! Here I've been carried away with carmine, leaving too few yellow feathers and spoiling the brilliant effect I had before. Let's work on that part of the wing and try to bring it back to the way it was originally.

8 We use a dilute wash of the three colors, with carmine as the dominant one, to paint the first brushstrokes on the trunk where the macaw is perched. Notice how we lift out the color at the base of the tail and leave an area of white paper to be able to add a brushstroke of ultramarine blue when it's dry. This will enrich the painting and give the impression that the bird is painted with more colors.

9 We take a wider, slightly wet, flat brush and carefully draw it over the areas where we want to remove color. Rinse the brush with a lot of water until it's clean, and then repeat the operation. Once the paper is dry, we can repaint without a trace of the previous correction.

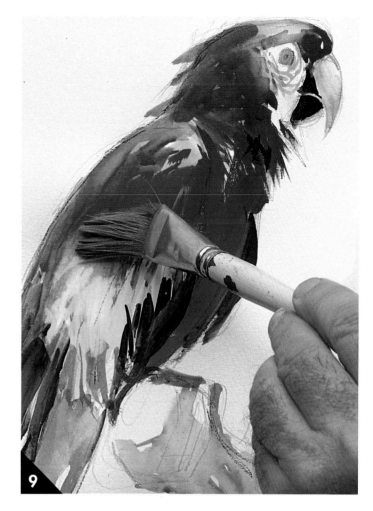

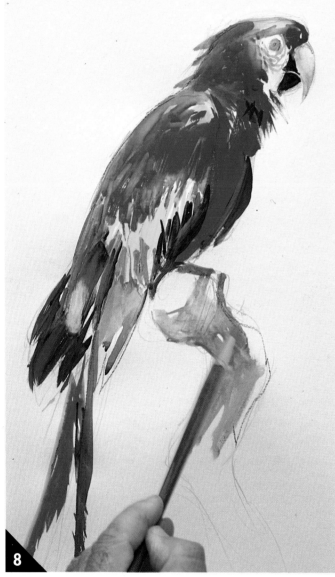

10 The wing is repainted with lemon yellow. Using a number 10 round brush, we paint the feathers on the bird's back with carmine and a small amount of water. With a mixture of lemon yellow, carmine, and very little ultramarine blue, we make a few complementary brushstrokes on the trunk.

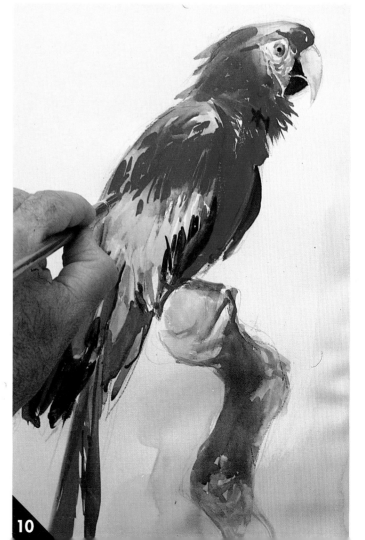

DRAWING AND PAINTING A GUINEA PIG

*T*he moment has come to paint a guinea pig like the friendly, gentle, and inquisitive animal you will find in the photographs. He posed for us, poked his nose into the palette, and almost stepped in its wet colors. If you manage to find one to paint, keep the animal in a cage. The most difficult part of a guinea pig to paint is his fur. In order not to have too many problems, pay attention to its color and direction and try to do it with a minimum of brushstrokes. Leave the paper clean and white to indicate white fur, adding only a few touches of color.

Let's try it!

MATERIALS

- 9" × 12" (block) (22 × 27 cm) hot-pressed watercolor paper
- 3B soft pencil
- Nos. 4 and 10 sable brushes
- A synthetic fiber flat brush ¾" wide
- Tube colors:
 Cadmium yellow light
 Cadmium orange
 Yellow ochre
 Burnt sienna
 Van Dyke brown
 Cadmium red light
 Carmine
 Yellowish green
 Olive green
 Sap green
 Cobalt blue
 Ultramarine blue
 Cerulean blue
 Indigo
- A rag, an old towel, or paper towels
- A metal watercolor box with compartments for colors

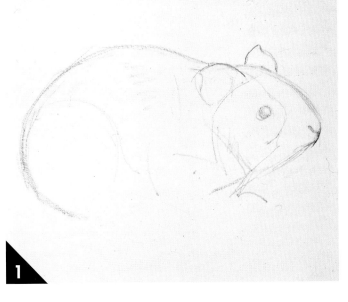

1 As we already mentioned, it's not difficult to draw a guinea pig, since his body is oval and his head is another smaller oval, out of which protrude the ears and the front paws.

2 We finish correcting the drawing, paying special attention to the location of the eye and the fine line that indicates the nose. Then we draw outlines to show where the white areas are in the guinea pig's fur.

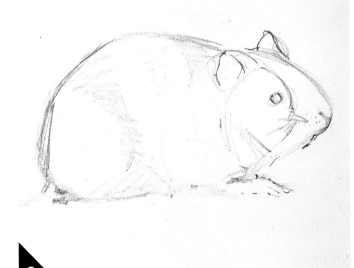

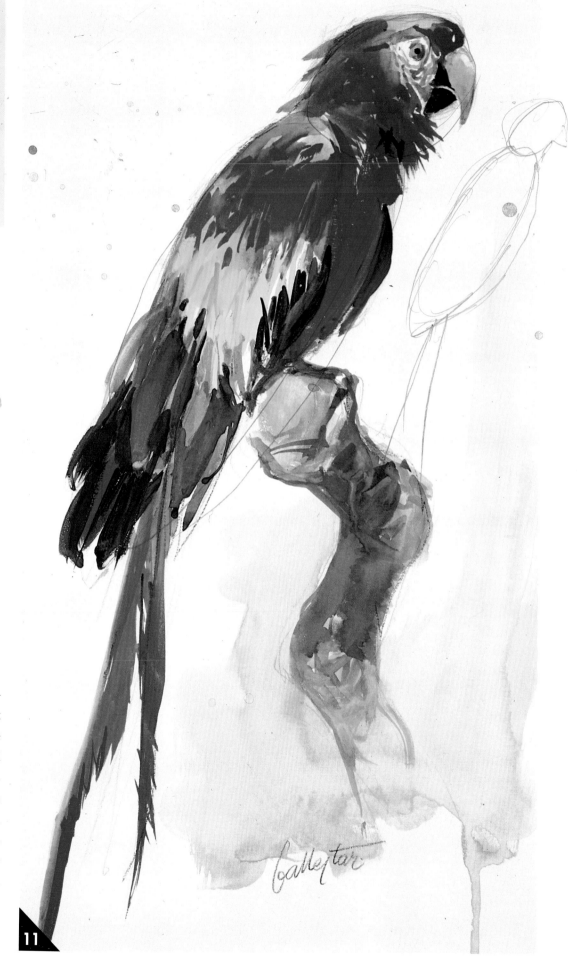

11 To complete the painting, we paint the light part of the beak over the mixture of the three diluted colors. This gives us a grayish brown tone. Next, we paint the macaw's foot and part of the perch using the same tone with heavy brushstrokes. This finishes the exercise in three colors. It came out well, don't you think?

Using burnt sienna for the redder parts of the fur, we paint the brown fringe and the ear that protrudes from the head. For the cool color on the back, we add a little Van Dyke brown.

The gray background is a mixture of the two colors just mentioned, diluted with a lot of water.

The head is done with a mixture of Van Dyke brown and ultramarine blue in equal parts. For the darkest areas, indigo is added, then painted with a small amount of water, the way the eye is done.

This part of the guinea pig is painted with a burnt sienna and ultramarine blue mixture, resulting in a gray that is cooler than the background. After painting the entire area and letting it dry a little, lift out the white areas with a clean brush (synthetic), so you don't have to use additional brushstrokes to indicate the animal's fur.

The entire area of the floor where the guinea pig is resting has been painted in a very diluted olive green, mixed with yellowish green and sap green to paint the area between the animal's head and foot. When it is dry, we add a more intense brushstroke with the colors we just mentioned: olive green and gray.

The pinkish color of the nose, a characteristic of this animal, is achieved by applying some very diluted cadmium red brushstrokes on a light gray wash. We go over the entire shape of the mouth and paint some red dots around the nose.

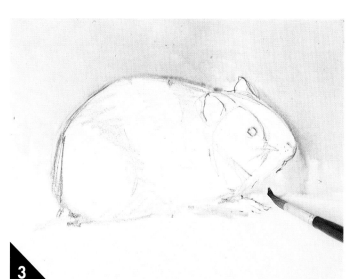

3 In these first steps, we paint the background around the guinea pig with a mixture of Van Dyke brown and ultramarine blue, using a lot of water to get a soft gray for the white areas in the head.

4 With the same gray, even more diluted, we paint the area underneath the animal. Once dry, this gray will serve as a base for the colors added later and enrich the white areas of clean paper that have been reserved. Next, using olive green with a lot of water, we paint a wash to indicate the floor.

TUBE COLORS

Squeeze small amounts of tube colors into the designated compartments. If you don't paint often, the colors dry; when you start to paint again, there will be tiny little sandy balls on the paper, which will affect the final painting. If you let too much time pass, the paint will have dried out. When you start to paint again, spray clean water on the dried paint, then squeeze fresh paint on top. The color will appear fresh again.

5 With the mixture of Van Dyke brown and indigo we get black. Here, it would be advisable to add more of the brown with a small amount of water as we begin to paint the characteristic markings of the guinea pig.

CARE OF A WATER-COLOR BOX

1. Use an old towel or a paper towel to wipe the corners of the paint box where water collects. If water is left, the moisture may eventually damage the enamel finish.
2. Do not let dry the paint that has been squeezed into the compartments of the paint box. If it should become hard, trying to remove it may ruin the finish on the watercolor box.

6 Throughout the painting try to vary the color. For example, in the guinea pig's head, where we already have white for the nose and the first variations of black, we will put a touch of burnt sienna on the ear. Little by little, this is how we enrich our painting.

7 Let's think for a moment. The head is beginning to have character. The inside of the ear hasn't been painted yet, so we can shade it and keep it from disappearing into the other darks around it. With a round brush and the same black we used before, we begin to paint the first brushstrokes on the animal's back, lightly indicating the direction of the fur.

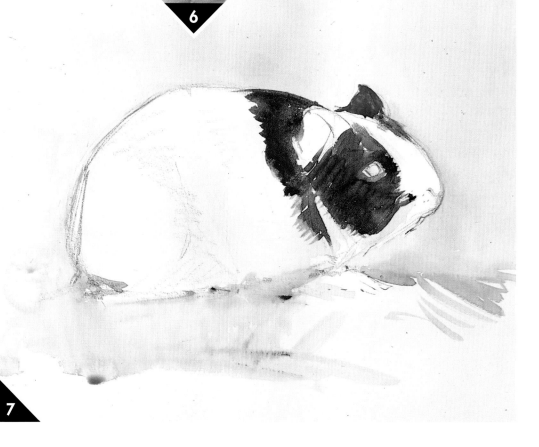

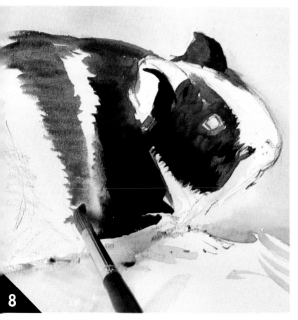

9 Continuing to define the guinea pig's body, we darken the rear with Van Dyke brown and ultramarine blue, applying the brush in semicircles as you can see in the adjoining photograph.

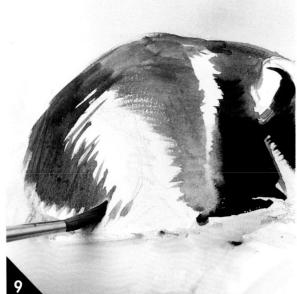

8 With a round brush, burnt sienna, cobalt blue, and very little water, we paint the reddish fringe across the middle of the guinea pig. Now that we're reaching the end, zigzag the brush to give an impression of fur on both sides.

10 Now we have painted the inside of the ear, harmonizing the color and differentiating it from the rest of the head. With a round number 10 brush and plenty of water, we blend the earlier brushstrokes on the guinea pig's back to get rid of the hardness and give the animal a soft, silky texture.

11 With the same black used previously, now somewhat diluted, we paint the inside of the eye, avoiding the little highlight of white in the center. Once this is dry, with the same black and very little water, we paint a very dark circle, not touching the white that was reserved earlier. Now we rinse the brush, and with cadmium red and plenty of water, we paint the nose as softly as we can.

12 With the same gray we already used, but more intense now, we make a light layer on the white area corresponding to the neck and a few brushstrokes around the nose. This will make the white of the forehead, which we left unpainted before, stand out.

13 We continue toning down the lower part of the guinea pig, blending blacks with the siennas in the fur to eliminate hardness and an overpainted look. Later, we repaint the blended area with a few brushstrokes.

14 With cadmium red, and gray, diluted with water, we paint the paw. With olive green and some sap green, we make the first brushstrokes on that same leg. With the previous mixture and plenty of water, we begin to suggest the shadow projected behind the guinea pig.

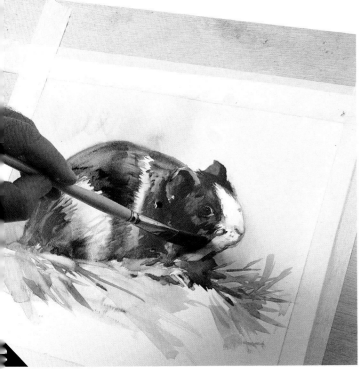

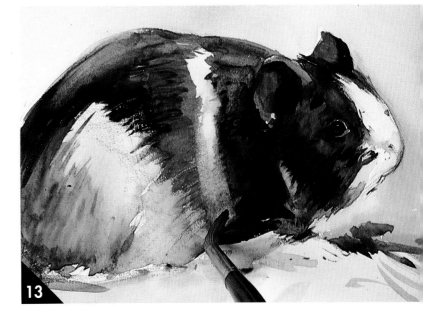

DRY COLORS

The dry colors in pans, if they are of high quality, will last a long time. Even in boxes that haven't been used for years, all you have to do is brush the top of the color with a wet brush and it will spring to life. For this reason, if you are going to buy a box of dry colors, it's worth it to spend a little extra money and buy a good one.

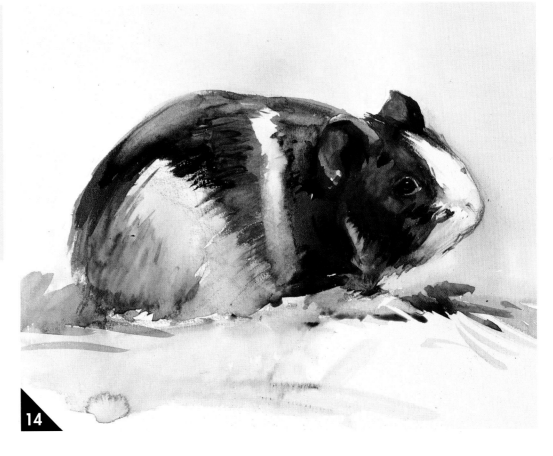

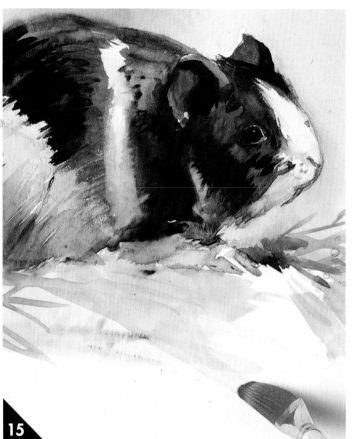

15 We take a synthetic fiber flat brush, ⅜-inch or ¾-inch wide, and with olive green and yellow ochre, well diluted, we paint part of the cage floor where the animal's food is.

16 Hot-pressed paper allows us to make corrections like the ones here. The way the guinea pig is hunched makes it necessary to shorten his back. I wet the paper, and with a synthetic brush I immediately lift out the color I don't want.

HOT-PRESSED PAPER

You will have noticed that most of these exercises are done with hot-pressed paper. It has a smooth surface, which is easier to correct when wet with a brush or a sponge. It is also easier to clean and can be repainted without revealing that something has been added or corrected. Smooth paper also has a glazed surface, which makes it much easier to manage than rough paper.

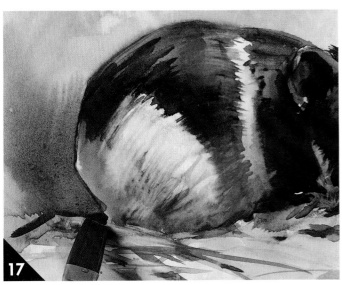

17 Once the correction has been made, we paint over that area, with ultramarine and Van Dyke brown. This mixture is blended up toward the middle of the painting to accentuate the dark grays on the left side of the watercolor.

18 With sap green we paint the area under the guinea pig's paw and head. Then, with the same mixture of ultramarine and Van Dyke brown used to correct the animal's back, we draw some very loose lines above the olive green to give the impression of grass or branches, which will contrast with the smoother background area. With this, we finish our exercise.

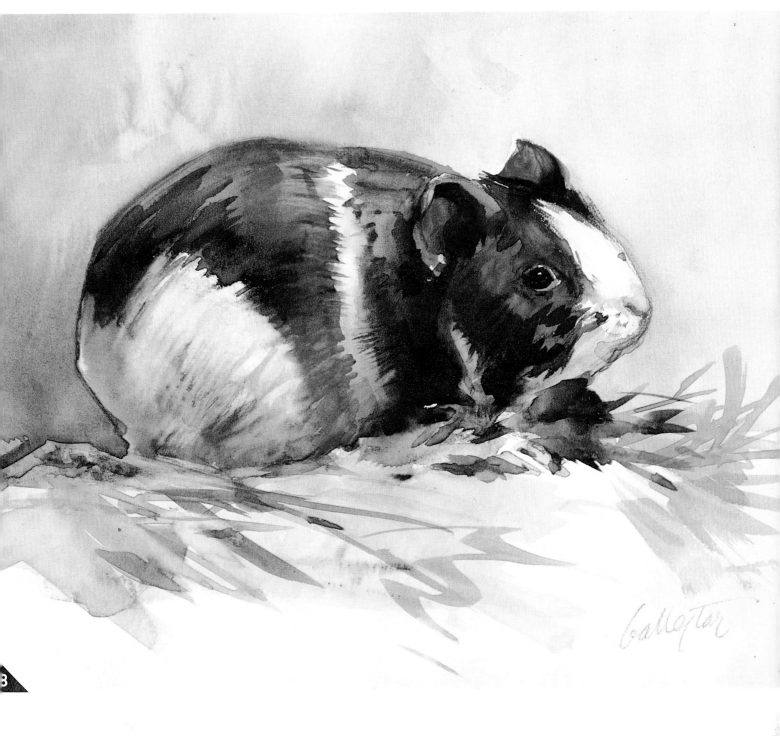

DRAWING AND PAINTING A GOLDFINCH

I chose a goldfinch for this last exercise because of its beautiful colors. Unfortunately, they cannot be seen clearly in this photograph, since the bird was frightened by the flash and kept hopping around in the cage. Nevertheless, we won't have much trouble with the drawing if we pay attention to a few areas: the head where the red feathers resemble a mask, the brown tone on the back, the yellow and black wings, and the black and white tail.

MATERIALS

- 9" x 12" (block) (22 x 27 cm) hot-pressed watercolor paper
- Soft 2B or 3B pencil
- Numbers 2, 4, and 10 sable brushes
- Tube colors:
 Cadmium yellow light
 Cadmium orange
 Yellow ochre
 Burnt sienna
 Van Dyke brown
 Cadmium red light
 Carmine
 Cobalt blue
 Ultramarine blue
 Indigo
- An old towel, paper towels, or a rag
- Metal watercolor box with compartments for colors and mixtures

The goldfinch's back is done with a mixture of yellow ochre, burnt sienna, and a dash of red, leaving the upper area lighter to get the depth we need.

The background is painted with a mixture of sienna and any one of the blues. This gray tone is stroked on with a very dilute wash. It serves to anchor the bird on the perch so that it does not appear to be floating in space, like the bird in the sketch at the bottom of the page.

Small touches of ultramarine blue and brushstrokes of the same color will be used as a base to enrich the dark tones in the tail, which we will paint later.

1 Before we begin our painting, it is advisable to mount the piece of paper we are going to use on a board. This is the most practical system as it stretches the paper very taut. Once the painting is done, we can remove the paper easily. It can also be attached with thumbtacks, but these can be inconvenient because if you plan to continue using the board for other paintings, it will get full of holes and lose its smoothness.

The color that stands out most on the goldfinch is the red area of the head, which gives the bird its characteristic masked look. With a number 2 brush and cadmium red, the entire surface has been painted, mixing a small amount of black in the upper area of the head. Once it's dry, brushstrokes of carmine are added.

This entire area has been painted with the same gray that was used for the background, adding some yellow ochre.

In both cases, for this area of the wings, I used cadmium yellow light, which blended with the siennas on the back. Once dry, using black and very little water, I painted some strokes without blending them, following the direction of the feathers and continuing toward the tail. Remember that the black is a mixture of Van Dyke brown and indigo.

2 With a number 2B or 3B pencil we draw the first outlines of the goldfinch, with a circle for the head and an oval for the body. We draw the wings and the tail rapidly, just suggesting the bird's feet.

3 Going over the previous sketch with a pencil, we refine the details of the head and the distribution of the markings on the face and the eye. We finish the bird and leave it ready to be painted.

4 We take a number 10 round brush, mix yellow ochre with some burnt sienna, and paint the back of the bird.

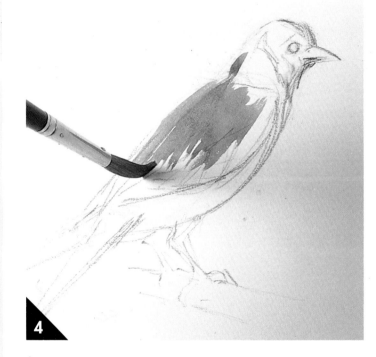

COLORS LOSE THEIR INTENSITY

Most colors lose between 10 and 20 percent of their intensity when they dry. While painting, it is important to keep the color slightly deeper than the desired tone. In this way, you can compensate for the difference and not have to repaint the color and lose the freshness that is such a vital part of this process.

5 While the back dries, we paint a light gray wash over the back part of the bird's head. Next we paint the yellow area of the wing.

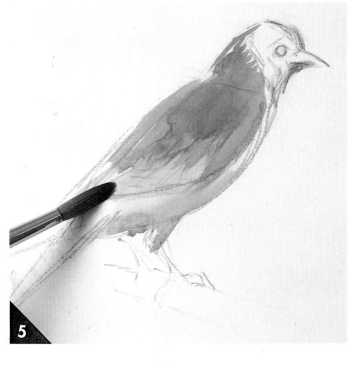

6 After you establish the painting's first light and medium values, it is always advisable to paint a few brushstrokes of a more intense color to contrast with the lighter values. In this case, strokes of black were added to the wings.

7 Note the progress from the previous step to this one. We mix gray by combining burnt sienna and cobalt blue. This is used to paint the background very freely, accentuating the form of the goldfinch.

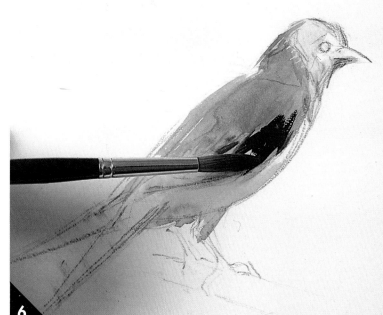

8 We also fill the white area of the head with the same gray, diluting it with more water in order to obtain a more subtle white tone than the white of the paper. We do this so that when the head is painted, this area will have a finished look. With Van Dyke brown and some ultramarine we begin to paint the tail.

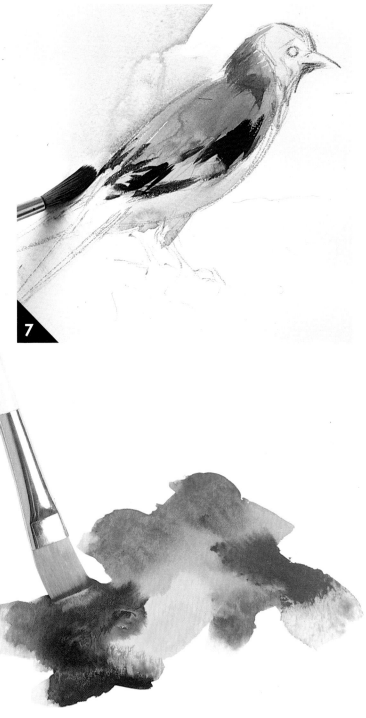

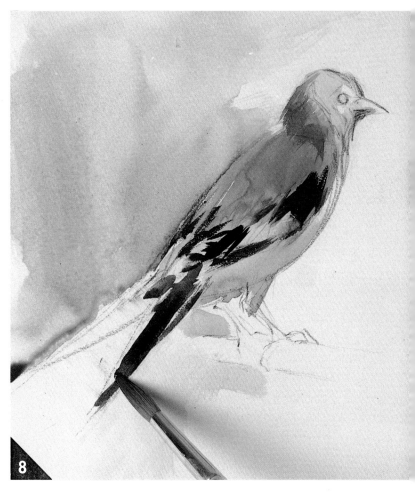

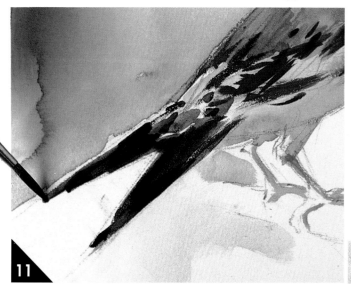

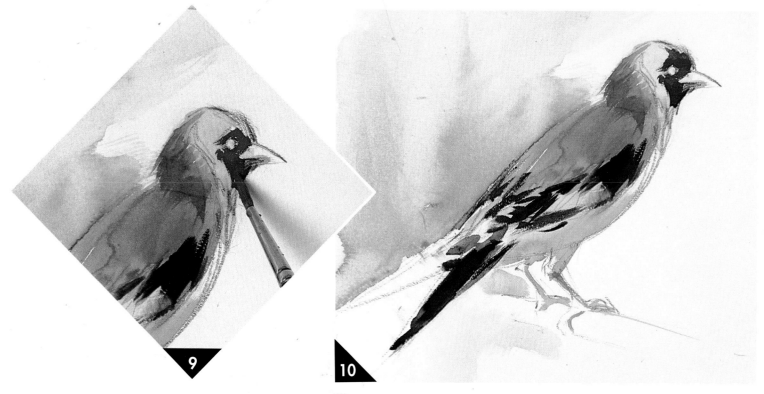

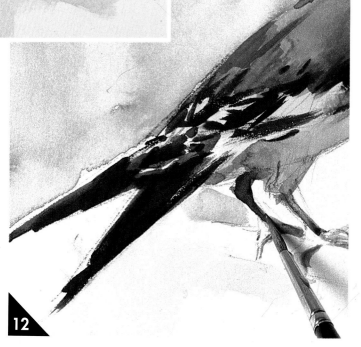

9 We return to the head. With a number 4 round brush we begin to outline the front of the head with cadmium red. We leave the paper white in the area of the eye and the point where the beak starts.

10 Throughout the exercise I recommend stopping from time to time to think about the process. We now have accomplished a great deal of what we are trying to achieve: depth, contrast, and color. We add a diluted yellow ochre to the feet and with a few more details we will almost finish.

11 With indigo, ultramarine, and Van Dyke brown, we finish the tail. We leave the ultramarine blue clean and unmixed in some places, as in the brushstrokes at the base of the tail.

12 We are putting on the finishing touches. We darken the bottom of the goldfinch's foot with Van Dyke brown and a little ultramarine blue, then we add a brushstroke of burnt sienna between the toes of the other foot.

TAKING CARE OF BRUSHES

Taking care of watercolor brushes is relatively simple. It's enough to rinse the three or four brushes that you use during the exercise and dry them carefully by pressing them between your thumb and index finger, just enough to get rid of the color and the water.

Next, place them in a jar with the handles down.

13 We complete the exercise by going over the white part of the head with black, leaving the paper white for the highlight in the eye. Next, we try to repeat the exercise, but this time more loosely, as if we are making a quick sketch. We will draw the bird with fewer details, and very freely.

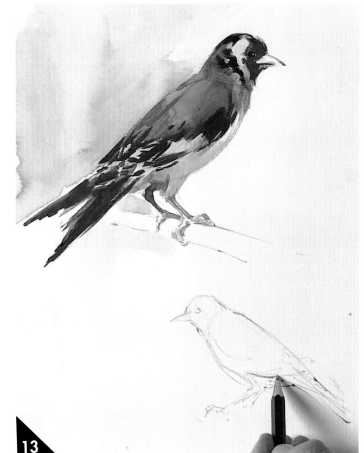

VARNISHES

There are various types of watercolor varnishes; some are applied with a brush and others with a spray. I'm not partial to varnishing, although the colors do shine more in the final result. If you do decide to put varnish on your painting, apply it in thin coats because the places where the color is most intense will shine more and where the hue is lighter, the varnish will hardly be seen at all.

14 As we did in the previous exercise and with the same mixture of yellow ochre and burnt sienna and a number 4 brush, we stroke the color from the rear of the bird's head to the base of the tail.

15 Now take a number 2 brush and paint the front part of the goldfinch's face with cadmium red. Don't worry about the correction as you paint this sketch. The goal of any quick study is to give the impression of spontaneity and vivacity.

16 Here it's not necessary to let the previous color dry. With very little water we apply a cadmium yellow light brushstroke to the bird's back on the edge of the brown. With Van Dyke brown we make a few brushstrokes to fill in some of the whites in the head.

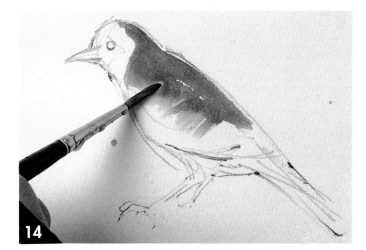

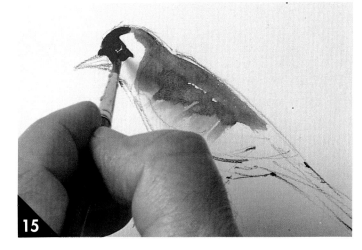

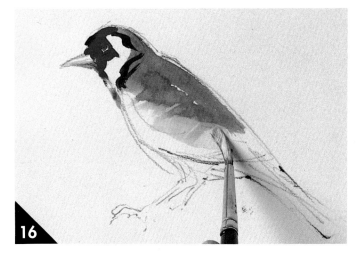

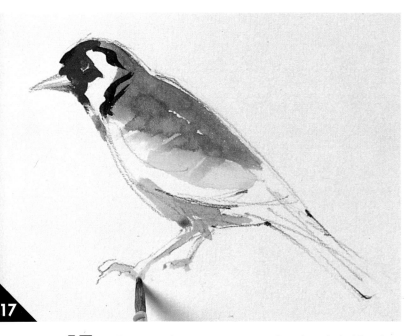

17 In this case, burnt sienna mixed with cobalt blue has been used for the gray on the lower part of the other goldfinch. Next, we make a few brushstrokes toward the feet.

18 Since what we are attempting is a quick sketch, it is worth mentioning that what we are really trying to do is capture a characteristic gesture or movement, etc. We paint the bird's tail in a quick and spontaneous way with a mixture of indigo and Van Dyke brown.

19 With a mixture of burnt sienna and Van Dyke brown we darken the uppermost area of the bird. Above the yellow area in the wings, using very little water, we make a few very black brushstrokes. This concludes our exercise.

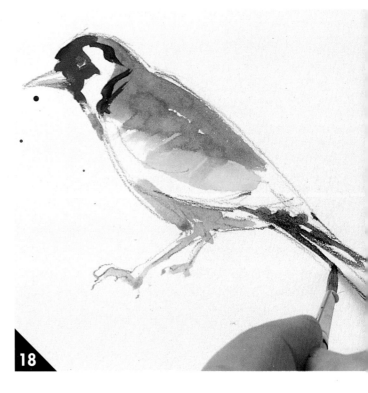

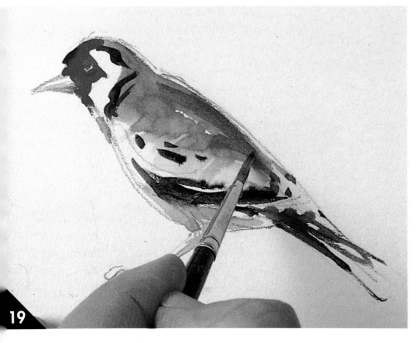

20 Once the painting is done, we can analyze it. The upper area of the bird has been done step by step and as a result it has a more studied look, while the lower area gives the impression that it was painted in a confident, spontaneous way. One final word of advice: If you really like to draw and paint, as I hope you do, practice as much as you can and don't worry—you will acquire enough skills to make some very good paintings.

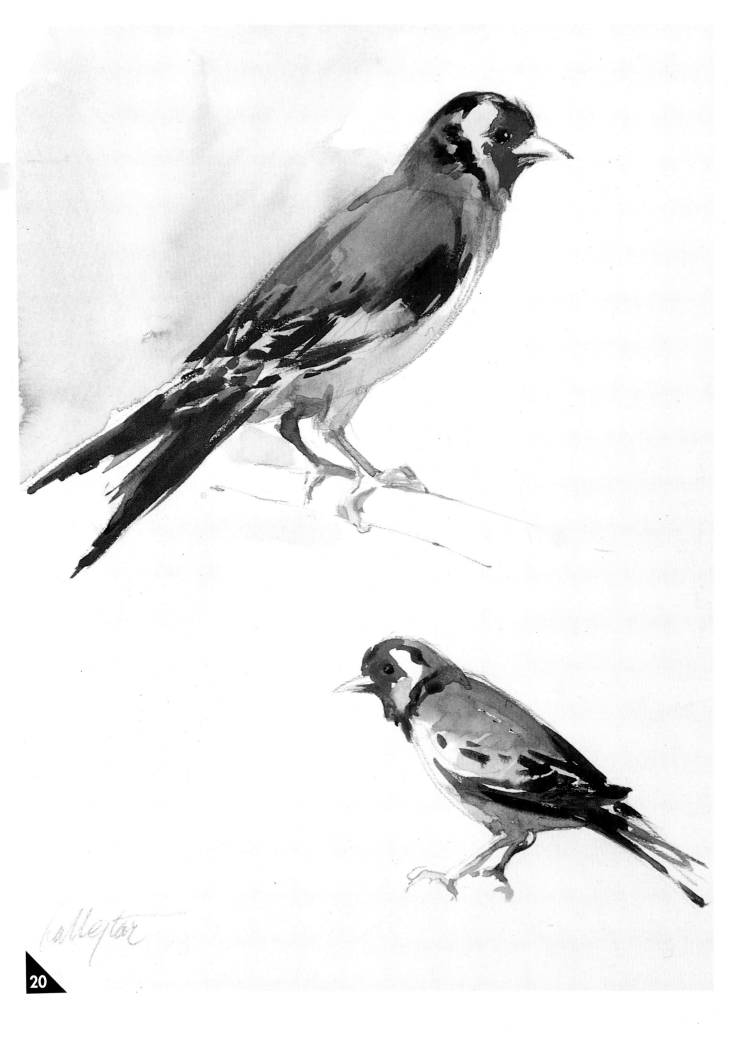

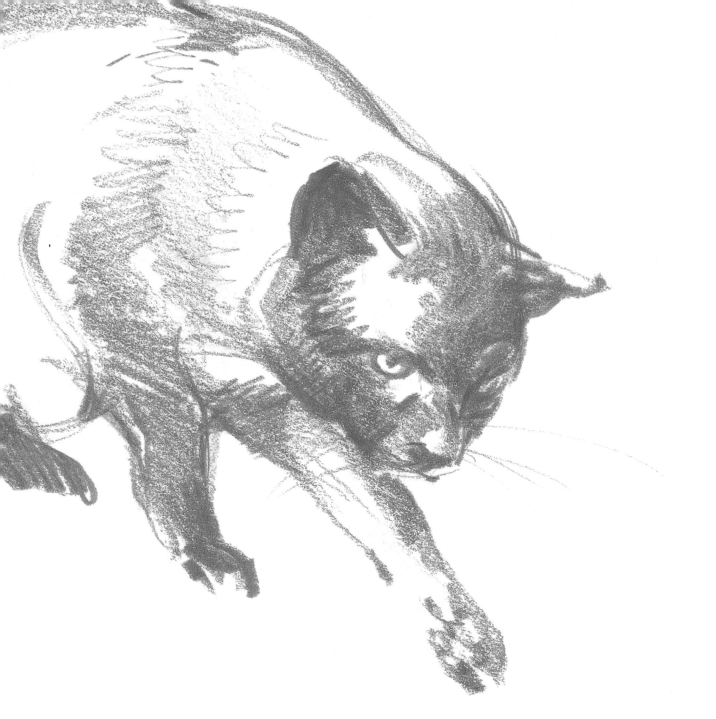

ACKNOWLEDGMENTS

I would like to thank Parramón Ediciones, S.A. and especially Jordi Vigué for giving me the opportunity to write this book and for his valuable help in correcting the text. My thanks also to Josep Guasch for his fine layout, which makes the book so attractive. Also, thanks go to Jordi Martínez who supplied me with most of the animals who are painted here. And to Joan, Jaume, and Toni, from Nos & Soto, for their splendid photography.

My thanks also go to Euroanimal of Barcelona for lending us the animals we used as models for the exercises in this volume. And to Vicenç Piera of Barcelona for his generous supply of artist's materials.

Vicenç B. Ballestar